W9-COS-882

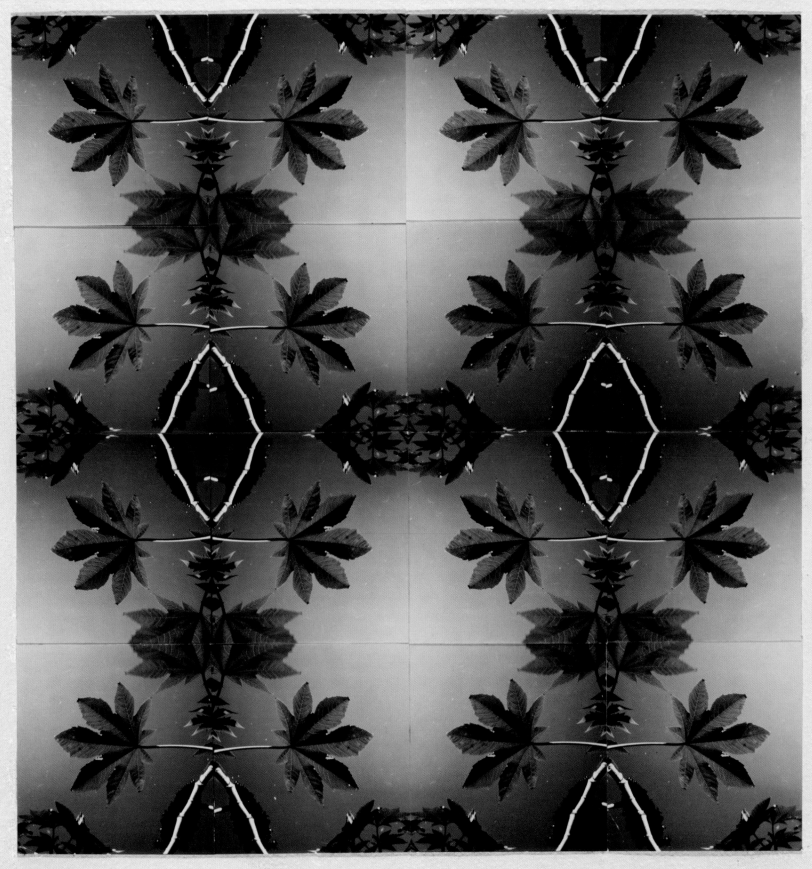

Horst: Patterns *from* Nature

Martin Barnes

For Lydia,

sharing the beauty of pausing
to look closely

Contents

7 Introduction

13 Nature Abstracted
The Origins of *Patterns from Nature*

27 Nature Applied
Horst's Photographic Patterns

37 Plates

98 List of Plates

99 Notes

100 Bibliography

101 Acknowledgements

102 Index

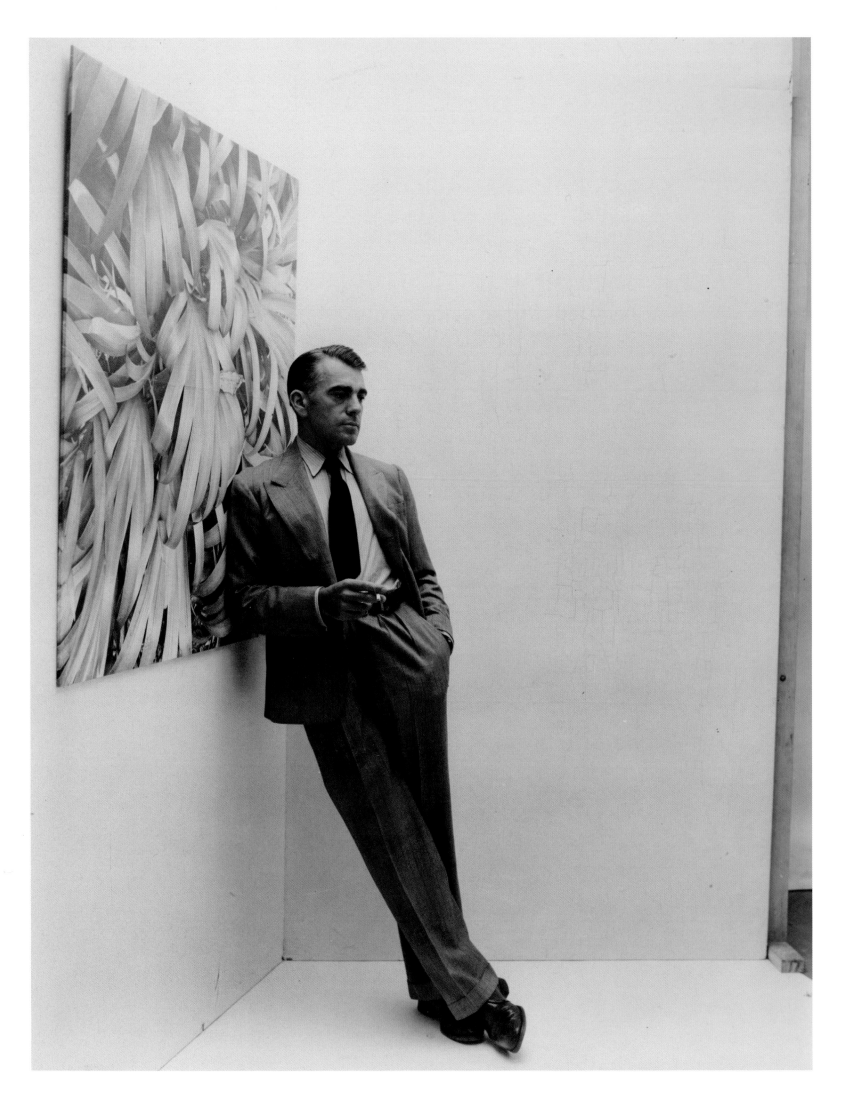

Introduction

1.
Irving Penn, *Horst, New York*,
1946, silver gelatin print,
25.4 × 20.3 cm (10 × 8 in.)

This book is the satisfying outcome of a rediscovery: an intriguing and little-known set of photographic collages made around 1946 by Horst P. Horst (born Horst Paul Albert Bohrmann, 1906–1999; fig. 1), one of the twentieth century's master photographers. These collages have not been studied or reproduced in almost seventy years, and the majority have never been published before. The questions of why and how such unusual and beautiful images were made, and the practical purposes Horst envisaged for them, are examined in the pages that follow. First of all, however, it is helpful to provide some context for these mesmerizing patterns – in order to understand what makes them stand out among Horst's other works – and briefly to outline his career and the thinking behind his better-known photographs.

Horst has become a revered figure, principally in the world of fashion photography. Aspects of his charmed and fascinating life have been documented in numerous publications, often with an emphasis on his impressive society connections and his role in defining the sophisticated, coolly untouchable imagery and personas that appealed to consumers of high-end magazines in the middle of the twentieth century. He charted sixty years of style for *Vogue* and *House & Garden* magazines, from the couture and celebrities of the 1930s to lavishly designed interiors during his resurgence in the 1980s. His best-known photographs, which have become highly desirable as collectors' items in the last thirty or so years, were made originally for publication, although he also made fine-art prints, sometimes on a large scale, for exhibitions. His archetypal studio work exudes classical elegance, a timeless sense of monumental stillness and, on occasion, surreal undertones.

This distinctive aesthetic was forged during Horst's formative decade as a young man in Paris. Aged twenty-three, he arrived in the city from his provincial home in Germany early in 1930 with the offer of employment in the architectural office of Le Corbusier. Paris at this time was the centre of artistic modernity in fashion, design and theatre, as well as the hub of sophisticated society. Famously handsome, and armed with ambition and charm, Horst moved easily in Parisian circles. Dissatisfied with his duties as an architectural draughtsman, he left Le Corbusier's practice after becoming professionally and romantically involved with the chief photographer for Paris *Vogue*, George Hoyningen-Huené (1900–1968). Horst initially

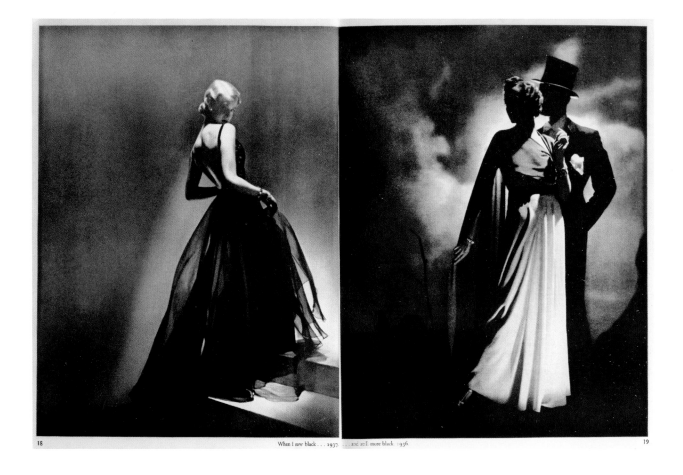

18 When I saw black . . . 1937. . . . and still more black. 1936. 19

2. *Above and opposite:*
Three spreads from *Horst:
Photographs of a Decade*,
New York (J.J. Augustin) 1944,
pp. 18–19, 66–67 and 88–89.
The photograph on the right-
hand page of the third spread
is a reproduction of one of
Horst's most famous images,
Mainbocher Corset (1939).

acted as a model for the Russian émigré, and was
then coached in photography by him before finally
taking over his position at *Vogue* in 1933.

Horst's rise through the ranks of fashionable
society, on both sides of the Atlantic, was as
rapid as his mastery of the photographic studio.
He photographed, and often befriended, such
luminaries of film and fashion as Marlene Dietrich,
Noël Coward, Bette Davis, Elsa Schiaparelli and
Coco Chanel. *Vogue* came to depend on him as one
of its most reliable and distinctive photographers.
Horst relished his sparkling social life, but he
also had an aptitude for toil: the sheer number of
images that survive in his personal archive, as well
as the archives of *Vogue* in Paris and New York,
speak of a tenacious work ethic. When war broke
out in Europe, Horst evaded conscription into the
German army and appealed to the New York office
of *Vogue* for a work permit. Through the magazine,
he gained passage in 1939 to the United States,
where he eventually became a citizen in 1943
(adopting at this time the name Horst P. Horst).
Although he travelled frequently to Europe, Horst
made his home in America, where he lived with
his partner and biographer, the British diplomat
Valentine Lawford (1911–1991).

The enigmatic poise of Horst's images is
derived from an unusual hybrid of artistic interests.
The photographer combined a romantic reverence
for the classical Greek ideal of the human form
with a darker, dreamlike and erotic vision, a product
of his collaborations with Salvador Dalí. Bringing
this mix of influences to fashion photography, Horst
evoked a world of fantasy and aspiration, creating
a dramatic atmosphere with prints so shadowy
that they sometimes failed to depict the details of
the clothes. Horst excelled in the use of powerful
lighting and studio sets (fig. 2). His signature image,
which epitomizes his style and is widely known
through reproduction, is *Mainbocher Corset* (1939;
see fig. 2). The model – seen from the back and
literally placed on a pedestal or shelf – takes on
an ethereal quality in the strong directional light,
which effectively sculpts the shape of her body.

So pervasive has this icon of twentieth-century
photography become in connection with Horst that
it is difficult to believe that the images he made for
Patterns from Nature were even seen through his eyes.
That book evokes an entirely different photographer:
one who embraces natural light, focuses close-up on
organic forms, and delights in the joyful rhythms of
abstraction through experimental technique.

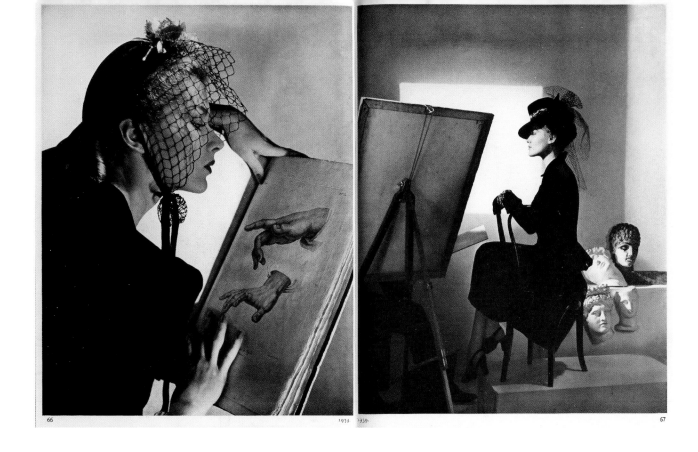

66 1939 1939 67

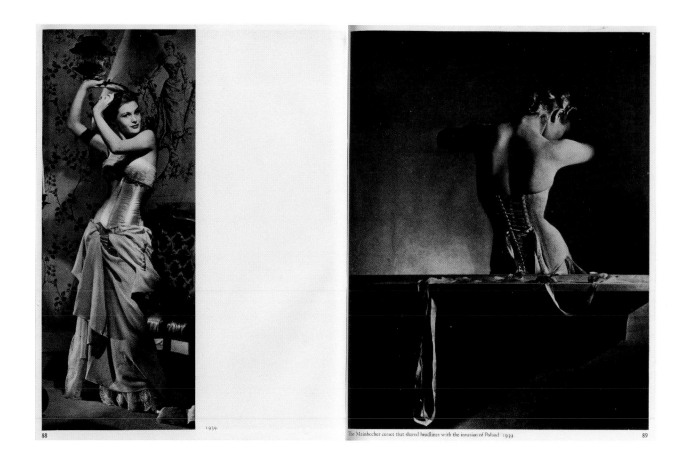

88 1939. The Mainbocher corset that shared headlines with the invasion of Poland 1939. 89

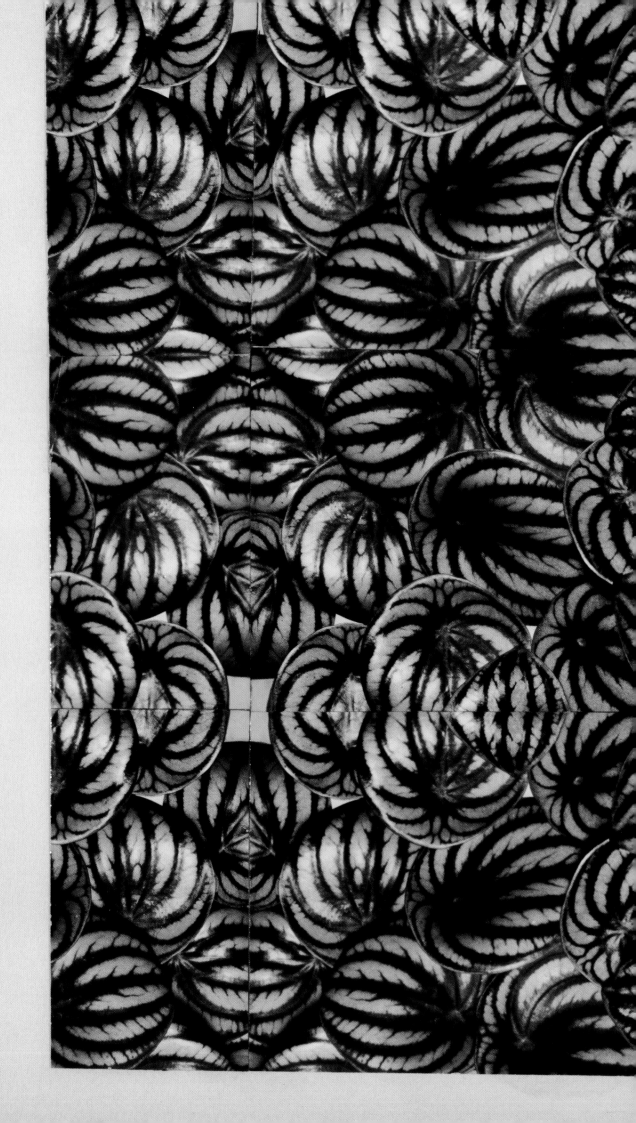

S. Ul

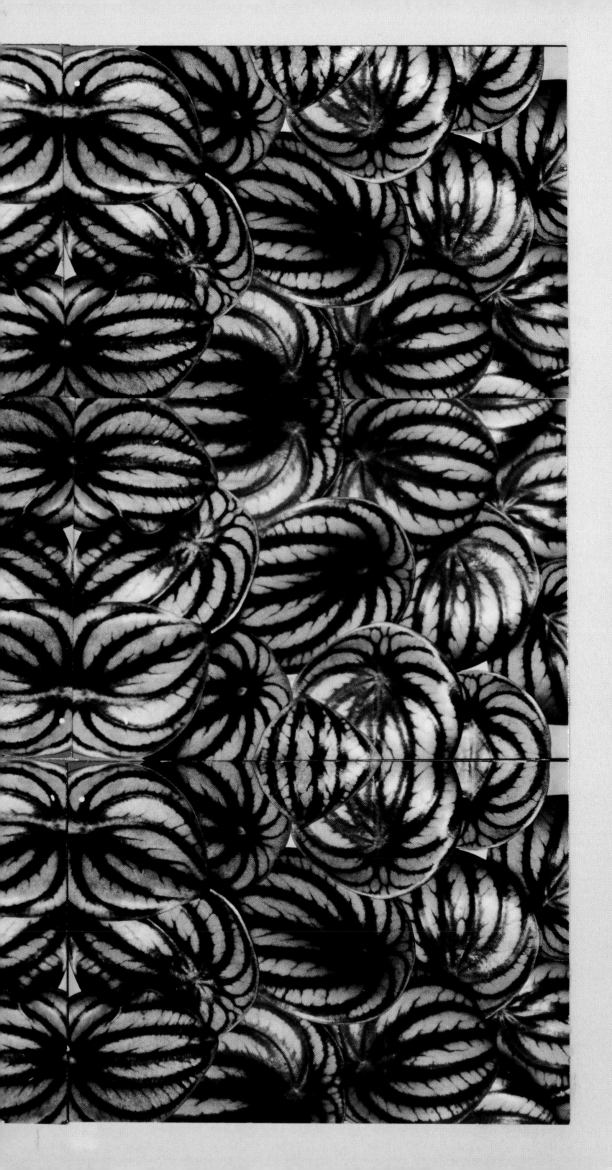

PATTERNS

from NATURE

PHOTOGRAPHS *by* HORST

Nature Abstracted
The Origins of *Patterns from Nature*

3.
The front of the dust jacket
of *Patterns from Nature:
Photographs by Horst*, New York
(J.J. Augustin) 1946.

Horst published several books of his work during his lifetime. His first, *Horst: Photographs of a Decade* (1944; fig. 2), was a compilation of his key fashion images and celebrity portraits from the 1930s. His second, the first and only edition of which has long been out of print, was *Patterns from Nature* (1946; fig. 3). At first glance, this book, and the series of individual photographs that forms most of its content, stand out as a curious diversion amid the high glamour for which he was, and remains, predominantly known. His signature style of strong directional studio lighting, theatrical sets and elegant human forms is notably absent from these close-up, black-and-white photographs of plants, shells and minerals. In its subject matter, visual language and aesthetic ambitions, *Patterns from Nature* sees Horst producing a deliberately contrasting visual statement and laying claim to his ability to explore artistically an aspect of the world entirely unconnected with fashion or high society. If there is any connection to be made here with his fashion photography, it is in terms of an overarching sense of elegant monumentality. As we shall see, however, the work can be seen to connect with his wider personal and professional interests in unexpected ways.

Throughout his career, Horst was not averse to adopting different styles to suit the various subjects and messages he was commissioned to convey. Indeed, such flexibility was a prerequisite for survival and ongoing relevance in the ever-changing world of fashion and magazines. Horst proved himself a master of studio-based photography in the 1930s, 1940s and again in the 1980s, when it became fashionable once more. His ability to control an environment and compose an image became an invaluable asset following magazine founder Condé Nast's house-style rulings for *Vogue* fashion photographers in the 1930s: a 10 × 8-inch (25.5 × 20-cm) negative and slow-speed film had to be used to preserve maximum detail; no photograph could be cropped; and images had to be contact-printed without any enlargement. It was only during the war years, when film became more expensive, that Horst was allowed to use smaller and more portable cameras, or, as a result, even consider capturing movement, by which time he had perfected his static and classical approach. His attempts during the 1960s at staying 'on trend' by depicting the dynamism of moving fashion models outdoors are poor in comparison. In such cases, Horst was demonstrably willing to try other

approaches, but was simply out of his considerably refined visual comfort zone.

Perhaps surprisingly, therefore, *Patterns from Nature* – with its images made in the open air using a 5 × 4-inch (12.5 × 10-cm) Graflex Graphic View camera and a Rolleiflex shooting 2¼ × 2¼-inch (6 × 6-cm) negatives – strikes a notably different yet harmonious chord alongside everything else in Horst's œuvre. It channels the more functionalist and Bauhaus-influenced visual world of his youth into photographic form, and is closely linked to the technical purity of 'photographic seeing' associated with the *Neue Sachlichkeit*, or New Objectivity, movement of 1920s Germany. It also connects with the contemporaneous modernist projects of Edward Weston (1886–1958; fig. 4), as well as certain works by Paul Strand (1890–1976; fig. 5), by taking the familiar forms of shells, rocks, trees and plants and subjecting them to such close examination that they become unfamiliar and revelatory. In *Patterns from Nature*, such revelations of natural forms under scrutiny exist alongside the demonstrably conscientious, scientific and classificatory. Horst is keen, for example, to list prominently in a technical index the type of film, developer, paper, camera and filters used to make each image.[1] This emphasis on technicality balances the fact that, for Horst, plants and flowers carried sensory and symbolic associations, and were highly emotive: 'We think of Easter when we talk of Lillies; dogwood conjures up a warm sunny day in Spring, and our visual conception of a rose is inextricably connected with its scent and with its color, be it a glowing crimson or a gentle white, and with tenderness and love.'[2]

By 1946, having worked in the service of fashion and commercial photography for more than fifteen years, Horst was perhaps in need of the chance to exercise and demonstrate his visual imagination beyond the confines of the *Vogue* studio. *Patterns from Nature* provided him with that opportunity, in the form of what today would be described as a photographer's 'personal project' – a self-directed study that is not generated by the needs of a commercial commission. (Its dedication, to Edna Woolman Chase, *Vogue*'s editor-in-chief from 1914 to 1951, indicates perhaps an acknowledgement of *Vogue*'s support for his need to recharge creatively.) The book is a demonstration of how Horst deliberately and refreshingly went back to basics, motivated by his own interests. In the book's introduction, he explains:

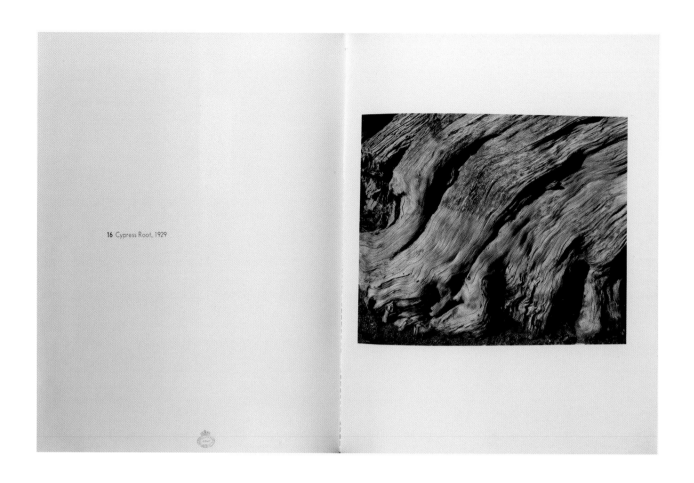

16 Cypress Root, 1929

4.
Edward Weston, *Cypress Root* (1929), from *My Camera on Point Lobos: 30 Photographs and Excerpts from E.W.'s Daybook*, Yosemite National Park and Boston (V. Adams and Houghton Mifflin) 1950, plate 16.

For the most part, the pictures found here [are] of common objects daily passing before our eyes. Nothing has been added to enhance them. They are photographed without artificial arrangements and special effects, in their own setting and in their proper light. Direct or diffused sunlight coming from above caresses their surface and in some instances dew or rain brings into relief their fine texture.[3]

According to Valentine Lawford, Horst had been thinking about *Patterns from Nature* in his spare time, 'before and since his discharge from the army', so presumably shortly before he was enlisted in the US military in 1943 and after he was discharged in 1945.[4] Lawford goes on to note, however, that most of the work 'was done in three months after his return to New York from Paris early in 1946'.[5] That same year, a short article in *Vogue* revealed the inspiration for the initial idea: 'Because a papaya leaf reminded him of a Gothic ceiling in Avignon, Horst, *Vogue*'s photographer, took a closer look at some everyday objects.'[6] In the book's introduction, Horst notes that 'the pictures were taken in Mexico, in New York at the Botanical Gardens, in New England's forests and along the Atlantic and Pacific coasts'.[7] Clearly, some extensive travel in the years or months

prior to the book's publication had allowed him to glean the variety of comparative images from different locations that he needed. Lawford traces Horst's first interest in natural phenomena to his childhood in the fields and forests of his native Thuringia, a state in central Germany. It was here, during the First World War, that 'he had learned to appreciate the value of plants – even weeds – as food for his family and for their rabbits'.[8] Lawford goes on to quote Horst himself on the wider cultural ideas and influences behind the book:

It was all a typical old-fashioned German thing … a combination of romanticism and realism and philosophy. Even Goethe entered into it, in terms of his recognition of the relationship between plant structure and animal structure, his longing to reduce the infinite variety of nature to unity, his faith in the value of comparison in interpreting the organic world. And of course I had known and admired Karl Blossfeldt's wonderful photographs of plants, and their revelation of the similarity of vegetable forms to art forms like wrought iron and Gothic architecture.[9]

Patterns from Nature, then, is in part a consciously acknowledged homage to Horst's

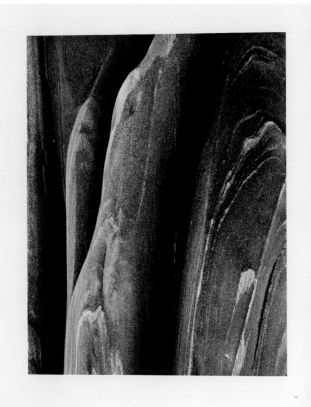

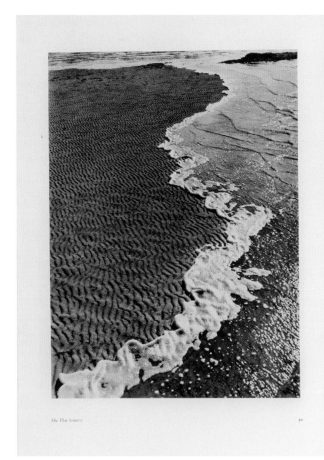

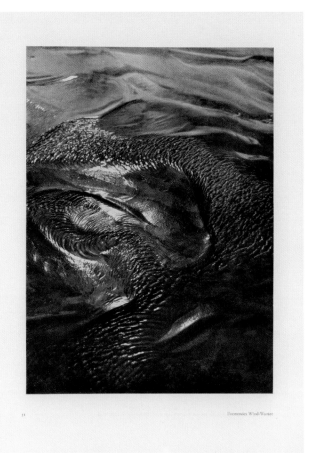

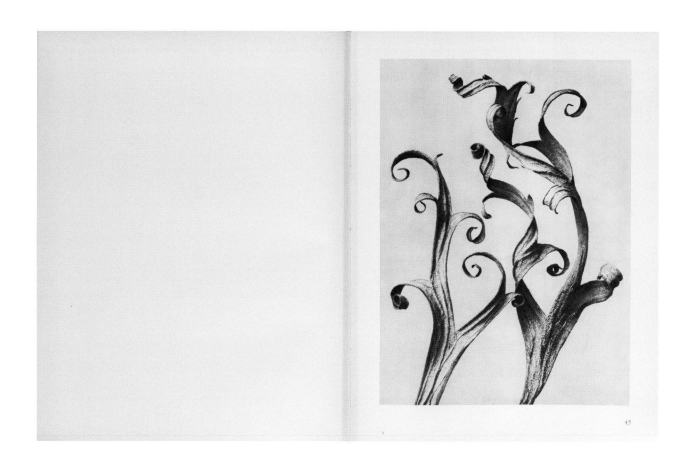

45

5. *Opposite, top:*
Paul Strand, *Rock by the Sea, Georgetown, Maine* (1928) and *Cobweb in Rain, Georgetown, Maine* (1927), from *Paul Strand: A Retrospective Monograph – The Years 1915–1968*, Millerton, NY (Aperture) 1971, pp. 56–57.

6. *Opposite, bottom:*
Alfred Ehrhardt, *Die Flut kommt* and *Formendes Wind-Wasser*, from *Das Watt*, Hamburg (Heinrich Ellermann) 1937, pp. 50–51.

7. *Above:*
Karl Blossfeldt, *Delphinium*, from *Urformen der Kunst*, 2nd edn, Berlin (Ernst Wasmuth) 1929, p. 45.

German heritage – one that allowed him, in the year immediately following the end of the Second World War, to associate himself with such untainted pre-war German cultural figures as the writer and statesman Johann Wolfgang von Goethe (1749–1832) and the teacher and photographer Karl Blossfeldt (1865–1932). Stemming the waves of inevitable anti-German feeling during this time, the book enabled Horst both to retain a sense of national pride and to stake a claim to an elevated artistic and philosophical heritage. Alexander Liberman, art director of American *Vogue* from 1943 to 1962, was also keen to invoke Goethe in the blurb printed on the back flap of the dust jacket for *Patterns from Nature*:

The return to Nature as a source of inspiration is a healthy sign in an age of weird manifestations of the ego. Horst in this book has had the humility to search for the abstract and the eternally beautiful within reality, and successfully makes Goethe's definition of Art come true: 'Art is Nature seen through a temperament.' Horst and his camera help us all to see.[10]

It is tempting to speculate that, for Liberman, Horst's nature studies were an eye-opening corrective, a kind of antidote to the ego-driven world of fashion and celebrity in which both of them had been immersed. Horst's publication was part of an established Germanic tradition of popular illustrated books that combined scientific enquiry with artistically rendered natural forms: *Kunstformen der Natur* (Art forms in nature; 1899–1904), a compendium of coloured lithographs by Ernst Haeckel (1834–1919); *Das Watt* (The mudflats; 1937), a collection of photographs by Bauhaus teacher Alfred Ehrhardt (1901–1984) of the patterns created in sand by water (fig. 6); and, most notably, as Horst himself acknowledged, Blossfeldt's seminal *Urformen der Kunst* (Art forms in nature; 1928) (fig. 7) and its follow-up, *Wundergarten der Natur* (Wonder garden of nature; 1932). In common with Haeckel and Blossfeldt before him, Horst was carrying out in a pictorial manner elements of Goethe's search for the *Urpflanze*, an idealized plant that contains all possible plant forms, and, by implication, the more abstract idea of the *Urform*, the archetype of all matter.

Blossfeldt's work, however, specifically posits a connection between plant forms and man-made structures and designs. In their use of dissected, arranged and enlarged plant specimens, Blossfeldt's images allow, for example, a cross section of

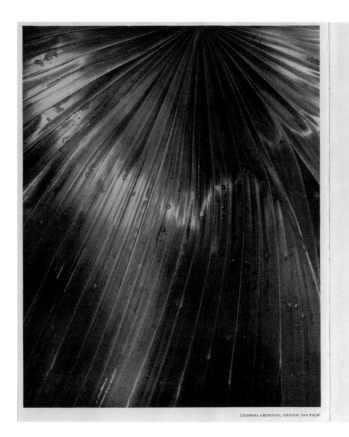

LIVISTONA CHINENSIS, CHINESE FAN PALM

PATTERNS
from NATURE

PHOTOGRAPHS *by* HORST

J. J. AUGUSTIN PUBLISHERS · NEW YORK

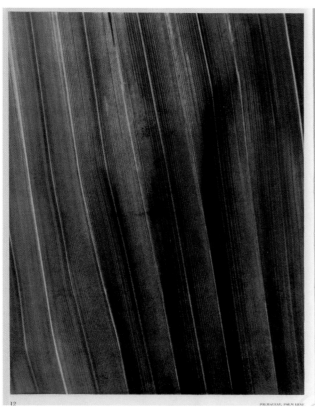

PALMACEAE, PALM LEAF

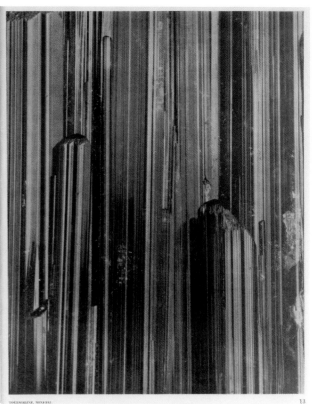

TOURMALINE, MINERAL

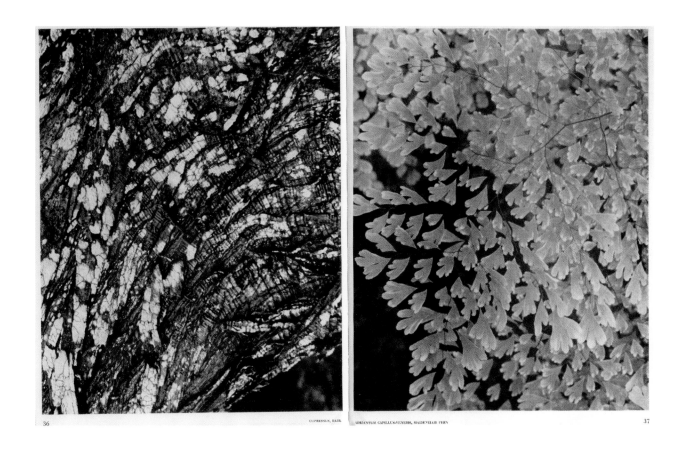

36 CUPRESSUS, BARK

ADRIANTUM CAPILLUS-VENERIS, MAIDENHAIR FERN 37

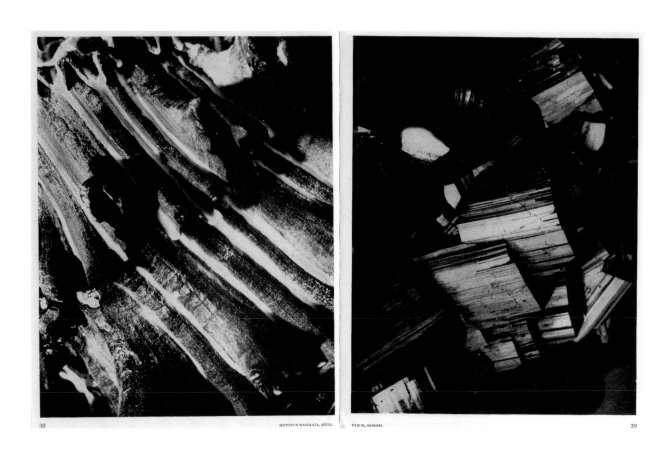

38 HIPPOPUS MACULATA, SHELL

PYRITE, MINERAL 39

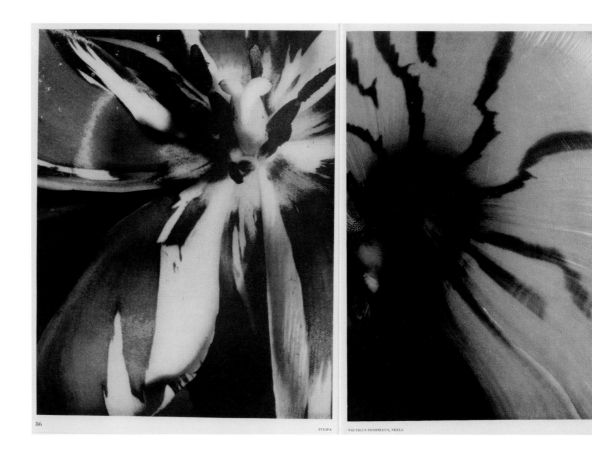

86 TULIPA

NAUTILUS POMPILEUS, SHELL 87

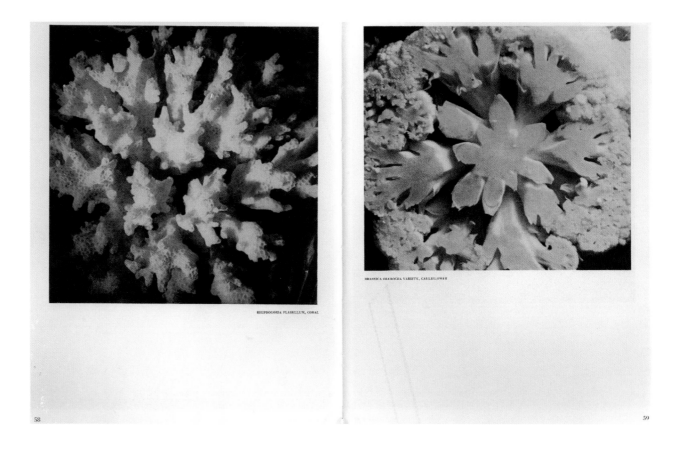

RHIPIDOGORIA FLABELLUM, CORAL

BRASSICA OLERACEA VARIETY, CAULIFLOWER

58

59

8. *Pages 18–19 and opposite:* Six spreads from *Patterns from Nature: Livistona Chinensis, Chinese Palm Fan,* frontispiece; *Palmaceae, Palm Leaf* and *Tourmaline, Mineral,* pp. 12–13; *Cupressus, Bark* and *Adriantum Capillus-Veneris, Maidenhair Fern,* pp. 36–37; *Hippopus Maculate, Shell* and *Pyrite, Mineral,* pp. 38–39; *Tulipa* and *Nautilus Pompileus, Shell,* pp. 86–87; *Rhipdogoria Flabellum, Coral* and *Brassica Olerocea Variety, Cauliflower,* pp. 58–59.

rough horsetail to appear like a Doric column, or delphinium leaves to be easily recognized as the natural precursors of the 'whiplash' forms favoured by Art Nouveau. Blossfeldt's training as a sculptor may account for his interest in more isolated, sculptural forms. His photographs often resemble individual portraits of plants, gathered together like an alphabet. Only occasionally do his images deal with mass repetition and all-over pattern. In Horst's case, the emphasis is rather on repeated structures, not only in individual images but also in their comparative pairing. Horst travels further into abstracted pattern, and also into making explicit visual connections between matching forms in contrasting natural materials. For example, the paired images *Palmaceae, Palm Leaf* and *Tourmaline, Mineral* draw attention to the repetition of fine vertical lines in both subjects; *Cupressus, Bark* and *Adriantum Capillus-Veneris, Maidenhair Fern* exhibit matching dappled patterns; *Hippopus Maculate, Shell* and *Pyrite, Mineral* feature similar striated building blocks; and *Tulipa* and *Nautilus Pompileus, Shell* share light and dark lines radiating from a central point (all fig. 8). In Horst's game of matching patterns, even coral and a cauliflower can be compared with each other (fig. 8).

The book's attempt to be scientifically accurate in its classification of plants is down to Jamie Caffery, whom Lawford notes was 'a young American friend … who worked for *Fortune* magazine but was also a knowledgeable amateur botanist. (Caffery later became a well-known garden designer in Europe.)'[11] Caffery accompanied Horst on his trip to Mexico and California, where they gathered images together in the way that actual plant specimens would be collected on a botanical field trip. Horst was meticulous in his filing of source negatives and contact prints, keeping them in a compact Kodak album that reveals some of his working processes (figs 9 and 11). As curator Susanna Brown has noted:

A Lilliputian album with golden letters embossed on its spine contains negatives and prints from Horst's Patterns from Nature *project. The album fits in the palm of one's hand and is specifically designed to protect square-format Rolleiflex negatives, measuring 2¼ × 2¼ in. (6 × 6 cm). It fastens with a press stud and begins with six lined pages for listing the contents, followed by 100 numbered paper folders, or folios, to hold negatives. As the text on the inside cover explains, 'The folders in this album are made of transparent paper. Negatives stored in them can be readily identified*

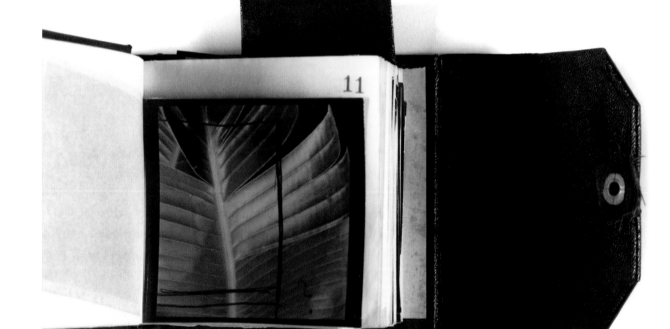

Horst P. Horst

The folders in this album are made of transparent paper. Negatives stored in them can be readily identified without removal, by holding the folders separately to the light and viewing the negatives through them.

Made in United States of America

SUBJECT	Folio
Frontispiece - Chinese Fan Palm	1
Pritchardia Gaudichaudii	2
Dieffen Bachia	3
Anthurium, possibly a "tail-flower"	4
Plant of Arum family, "	5
Agave Pupicola, Mexico	6
Ornithoptera	7
Agave Attenuata, Mexico	8
Agave	9
Probably a Sanseviera, Native of Africa	10
Strelitzia Nicole, S. Africa	11
Palm	12
Tourmaline, Brazil	13
Tail-Flower, Anthurium	14
Philadendum Cordatum Variegates	15
Unnamed Mexico	16
	17

9.
Horst's Kodak Negative Album from 1946, containing negatives and contact prints used in preparation for *Patterns from Nature*.

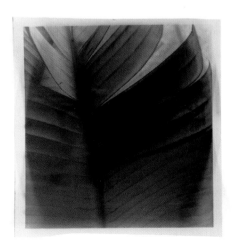

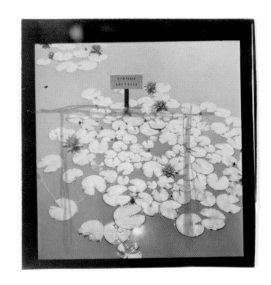

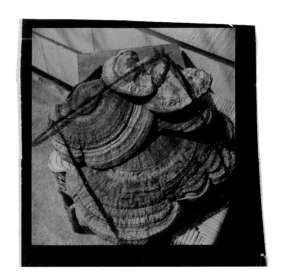

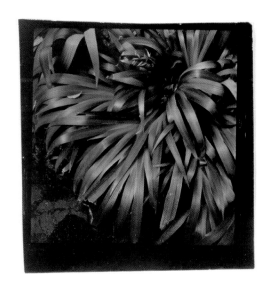

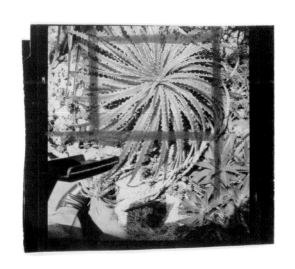

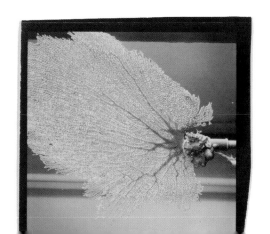

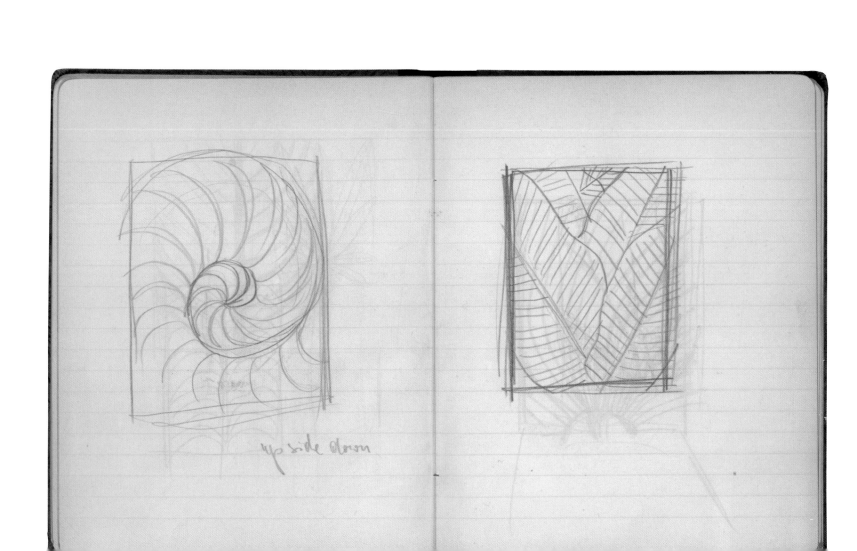

up side down

10. *Opposite:*
One of Horst's sketchbooks (undated), showing an idea for the layout of *Patterns from Nature*.

11. *Right:*
Horst's Kodak Negative Album.

without removal, by holding the folders separately to the light and viewing the negatives through them.' As Horst filled the album with negatives and their corresponding contact prints, he wrote the subject of each image in careful, tiny script on the contents pages: 'Chinese Fan Palm … Tourmaline … Allium Cepa …' The order of the images in the album matches the order in which they were reproduced in the 1946 publication Patterns from Nature. *The album also includes a small number of photographs – of subjects such as lily pads on a pond – that were not reproduced in the book.*

Many of the contact prints include Horst's crop marks in thick black or red lines, to indicate which section of an image was to be used in the final publication. These uncropped prints harbour surprising details and occasionally a human presence, giving them a character very different to their more purist, published counterparts. For example, the uncropped image of Hechtia glomerata, *photographed directly from above in the Bronx Botanical Gardens, includes Horst's shiny shoe. We discover that he photographed bamboo leaves,* Bambusa, *through a greenhouse window, and positioned the field mushroom,* Agaricus campestris, *on a wooden table top.*[12]

One of Horst's undated sketchbooks contains pencil drawings that appear to show him working out ideas for the photographs or the layout of the book (fig. 10). *Patterns from Nature* gains its full meaning through the pairing and repetition of images, and thus makes most sense in book form. However, Horst also made a set of 12 × 10-inch (30.5 × 25.5-cm) exhibition prints on a slightly textured, opalescent paper. As individual works of fine-art photography, these prints, especially when exhibited in a gallery context, continue to possess an afterlife independent of the book. Horst showed these prints at a gallery in New York as late as 1977.[13] In addition, he produced at least one mural-sized enlargement, which, in a portrait of him by Irving Penn (fig. 1), he can be seen leaning against.

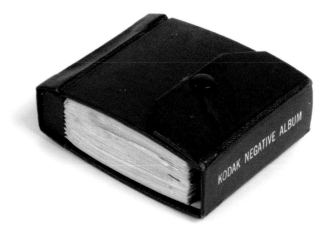

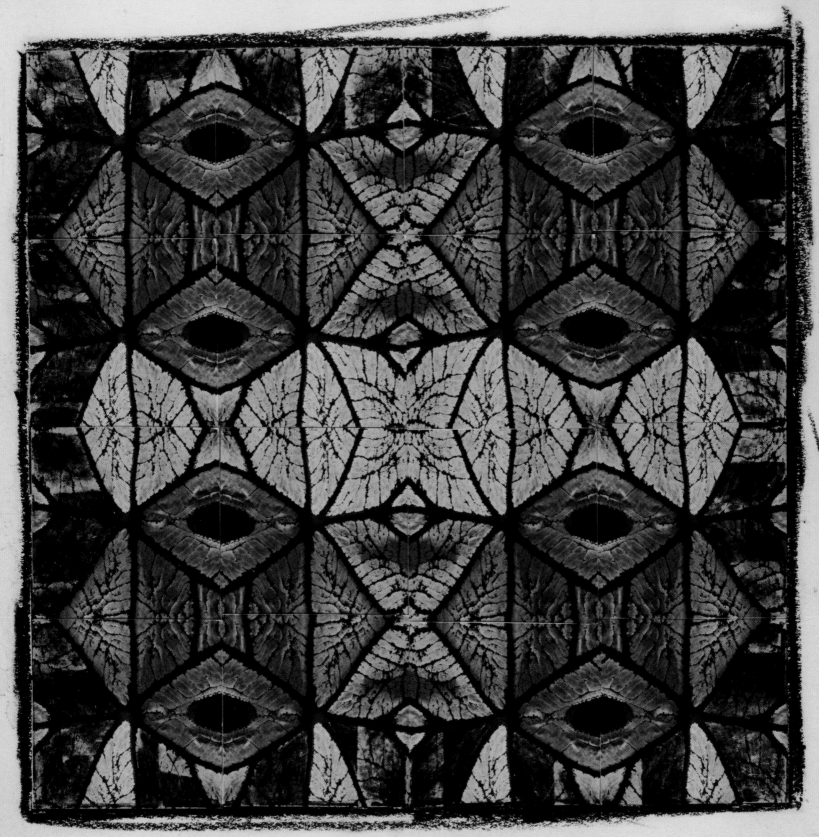

Nature Applied
Horst's Photographic Patterns

12.
Horst P. Horst, *Photographic
Pattern (Calladium)*, 1946

*P*atterns from Nature, and the exhibition prints to which it gave rise, amount to both an artistically conceived guide to the natural world and a modernist photographic quest for the *Urform*. However, the book's most original and creative mark is made by the unexpected step that Horst takes with its nine closing images (see fig. 15), which he prefaces as follows:

The ten following pages are photographs shown in simple repeat. The resulting patterns are immediately applicable to industrial fields such as textiles, wallpaper, carpets, plastics, glass, ceramics, china, leather, book-binding, and jewelry. It is also a demonstration of how modern design can be achieved through modern means.[14]

For Horst, these patterns acted as a pleasing link between his interests in photography, fashion, design and interiors. Valentine Lawford again names a collaborator who assisted Horst in his endeavours: 'Another American friend, Warren Stokes, who afterwards worked in the art department of *Vogue*, did the layout of the book, and helped Horst produce nine photographic

patterns for potential use as textile designs, each made from a detail of one of the photographs.'[15]

In fact, strictly speaking, Horst did not use 'details' from the photographs as they appeared in the book. Most of the original collages – or rather tessellated, mosaic-like photographs – reproduced in the final pages of *Patterns from Nature* survive in the photographer's archive. Comparing them with the plates in the book shows that, in the majority of cases, Horst made four contact prints from one of his $2\frac{1}{4} \times 2\frac{1}{4}$ or 5×4 negatives – two the 'correct' way round, and two 'flipped' across the vertical axis to produce a mirror image. These he arranged in a square or rectangle, with the correctly printed images the right way up at top left and upside down at bottom right, and the flipped images in the same orientation at top right and bottom left. He then repeated this grid of four, joining each arrangement edge to edge (fig. 13). In a few instances, he chose to deviate from this formula, creating, for example, a single row of 'mirrored' images with a second row below that is a complete mirror image of the one above but shifted along horizontally by the width of a single contact print (fig. 14). The plates in the book simply reproduce these mosaics to scale.

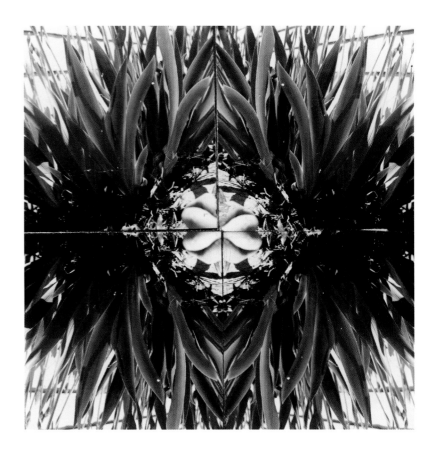

13.
A reconstruction showing
the process by which Horst
assembled most of his
photographic patterns.

Although the process is relatively simple, the effect is striking: abstracted and kaleidoscopic patterns that emerge like reflections in multiple mirrors, oscillating between three-dimensional photographic images and complex flat patterns. Their appearance is reminiscent of the inkblots that form the basis of the Rorschach test, a type of personality assessment used widely from the 1960s onwards. Horst's method of collaging photographs was also employed by the writer William S. Burroughs, but to rather different ends. Working in the 1960s, Burroughs made his photographic collages in collaboration with the mathematician and engineer Ian Sommerville, who described the activity as producing 'one great continuum'.[16] For Burroughs, creating what he referred to as 'infinity pictures' opened up expanded plains of reality; it also paralleled his free use of narcotics as a form of inspiration in his writing.[17]

While Horst may not have perceived the mathematical, psychedelic and transcendental properties of his collaging method, he was certainly open about how the resulting patterns might be practically applied. One of the original photo-mosaics is specifically annotated 'silk' (see pages 10–11), while others are designated 'wallpaper' and 'scarf' (see list of plates, page 98). The *Vogue* article of 1946 referred to earlier (see page 15) remarks that the collages 'might be mistaken for eighteenth-century wallpaper stripped from a Loire chateau', adding that they were 'actually being used as abstract patterns for contemporary materials'.[18] A more specific reference, suggesting that Horst's designs were actually put into production, can be found in a *House & Garden* article, 'Nature turns Designer', which makes explicit that 'These photographs will be translated into an interesting and arresting group of decorative textiles by Wesley Simpson Inc.'[19] A notice in the *New York Times* of 10 June 1947 confirms that fabrics were indeed produced and offered for sale:

Photographs of a Mexican scene and still-life subjects have inspired a new group of decorative fabrics by Wesley Simpson just introduced at Macy's. Based on photographs by Horst, the designs feature a cross-like arrangement of motifs, as well as unusual color combinations.

A view of a Mexican archway has been transplanted into a strong plaid pattern. In the photograph, three sunlit pillars in a row, plus the deep horizontal shadows they cast, form a striped right-angle design. This has

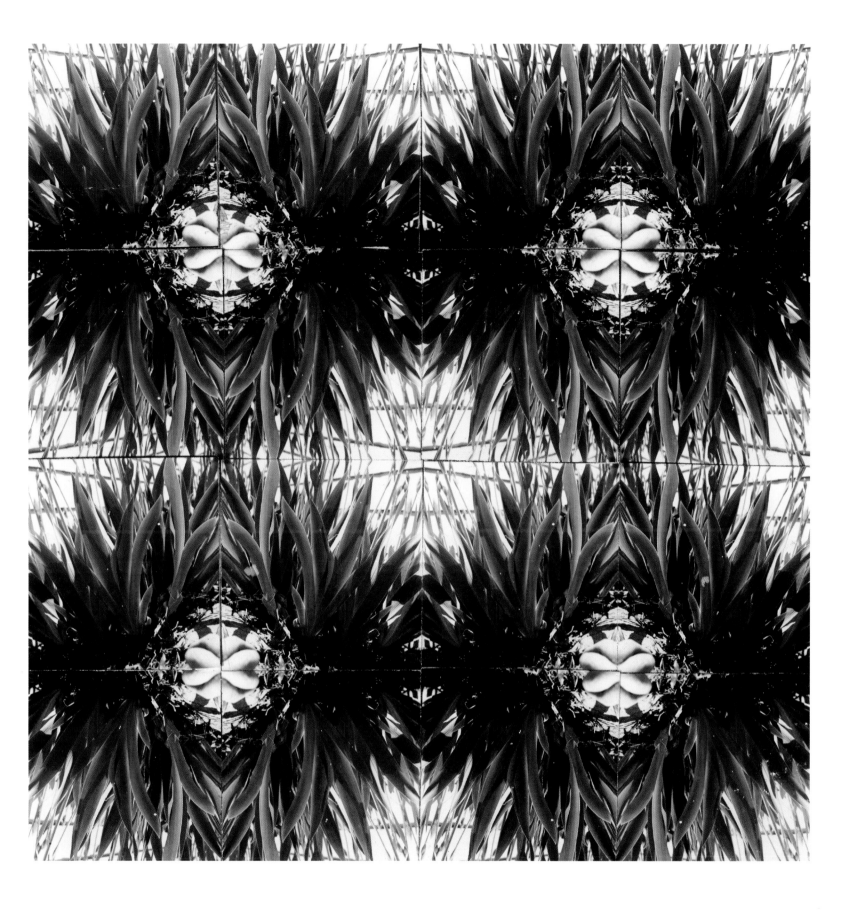

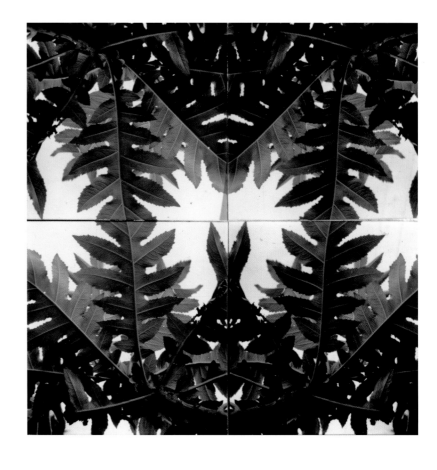

14.
A reconstruction showing
one of the alternative ways
in which Horst created his
photographic patterns.

*been printed in four directions to create a large pattern
stressing vertical lines. One version combines blue terra
cotta on a brown background.*

*A photogenic pot of ivy has been repeated similarly
to form a rough square. For a summery effect, it comes
in deep green and bright yellow on a gray ground.
A design of large shells is shown in navy and peach on
a pale blue ground accented by scrolls in olive green.*

*A plant resembling a cabbage in appearance forms
an abstract design. Three different colorings combine
rose, green and pink, blue, pink and white, or lime with
gray and white … the fabrics are a combination of
cotton and rayon thirty-nine inches wide.*[20]

The variety of coloured patterns that the
black-and-white photographs were translated into
is striking, as is Horst's deviation from natural
forms to include architectural motifs. A recent
search of the extensive Wesley Simpson archive
of swatch books, now held at the New York Public
Library, revealed none of the fabrics themselves,
although two original Horst collages were
discovered, one of which (page 91) appears to be
the 'Mexican archway' described in the *New York
Times* notice; the other (page 39) is *Agave, Victoria
Regina*, which was reproduced as one of the nine

plates in *Patterns from Nature*.[21] It is thrilling to
consider the possibility that garments, furnishings
and other designed items embellished with
Horst's photo-collages, and made during his
lifetime, may still exist and be brought to light
in the future.

Wesley Simpson Inc. produced decorative
textiles in New York. The company operated
from the 1930s until the late 1940s, printing
modern patterns on rayon and crêpe grounds,
and supplying fabrics to some of the better
Seventh Avenue clothiers and fashion houses,
including Davidow, Mary Lee, David Crystal,
Hattie Carnegie and Townley Frocks. The company
also commissioned original scarf and drapery
designs from such artists as Salvador Dalí, the
costume designer Marcel Vertès, and the writer and
illustrator of children's books Ludwig Bemelmans.
Advertisements for the company feature a line of
inexpensive furnishing fabrics.[22]

Photography had been used previously for
textile design, most notably Edward Steichen's
abstractions of weeds, pins, sugar cubes and thread
for the Stehli Silks Corporation's 'Americana
Prints' collection (a series of artist-designed textiles
produced between 1925 and 1927), and images by

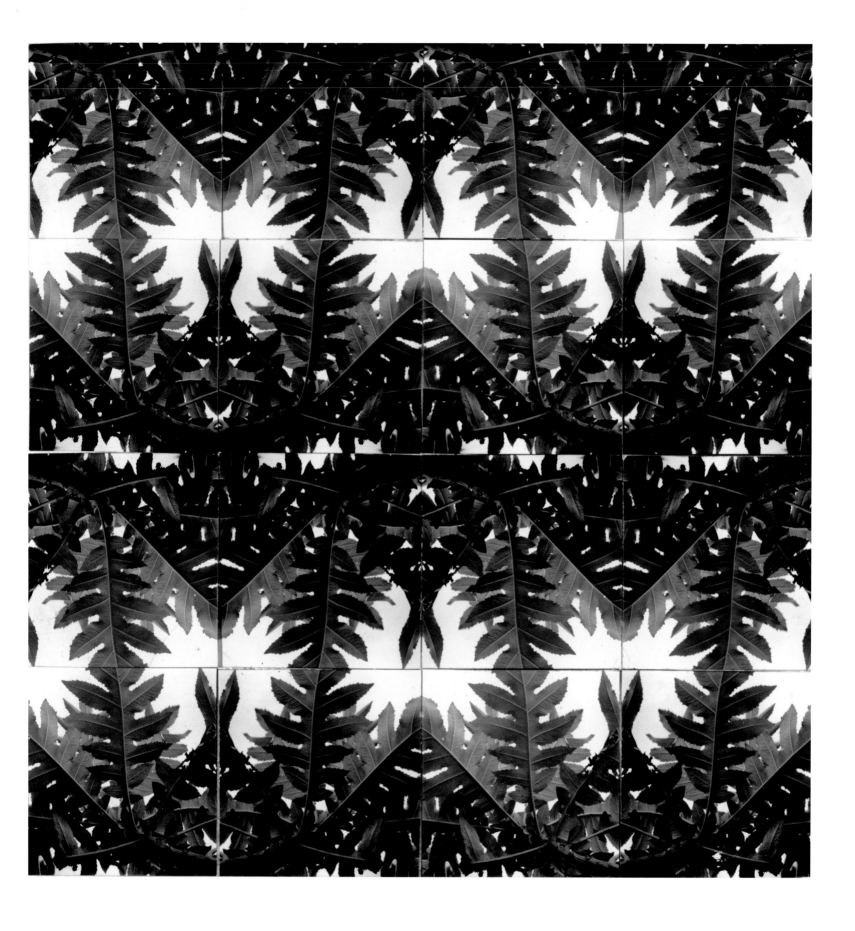

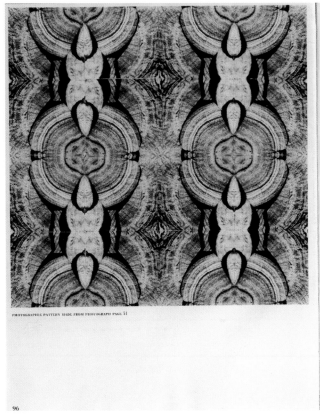

PHOTOGRAPHIC PATTERN MADE FROM PHOTOGRAPH PAGE 51

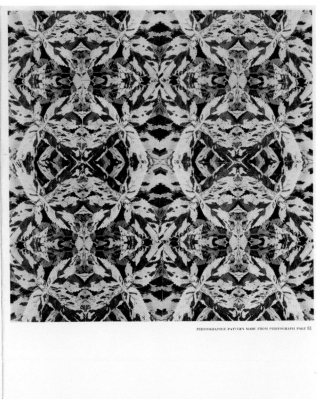

PHOTOGRAPHIC PATTERN MADE FROM PHOTOGRAPH PAGE 81

96

97

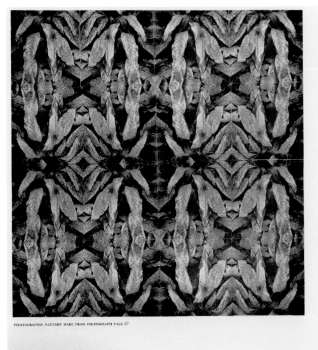

PHOTOGRAPHIC PATTERN MADE FROM PHOTOGRAPH PAGE 67

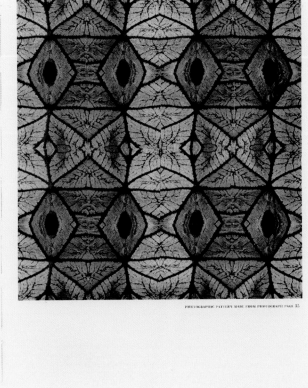

PHOTOGRAPHIC PATTERN MADE FROM PHOTOGRAPH PAGE 35

102

103

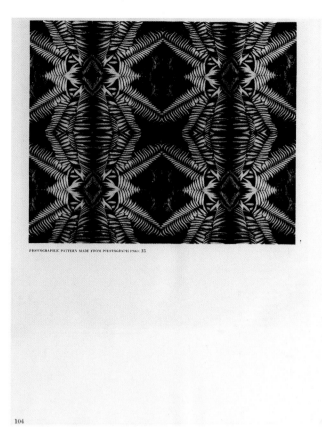

PHOTOGRAPHIC PATTERN MADE FROM PHOTOGRAPH PAGE 12.

104

LIST OF ILLUSTRATIONS

	PAGE
Livistona Chinensis, Chinese Fan Palm	Frontispiece
Pritchardia Gaudichaudi, Palm Leaf	2
Dieffenbachia	3
Anthurium	4
Anthurium	5
Agave Rupicola	6
Wing of Ornithoptera Cellularis, Butterfly	7
Agave Attenuata	8
Agave	9
Sanseviera	10
Strelitzia Nicola	11
Palmaceac, Palm Leaf	12
Tourmaline, Mineral	13
Anthurium	14
Philodendron Cordatum	15
Unidentified	16–17
Unidentified	18
Xanthosoma Lindenii	19
Papaya	20
Papaya	21
Iris Germanica, Iris Leaves	22
Bambusa, Bamboo Leaves	23
Iris Japonica	24
Agave Tequilana	25
Agave, Victoria Regina	26
Echeveria Gibbiflora Crispa	27
Trichocereus Candicans	28
Trichocereus Candicans	29
Aechium Holochrrysum	30
Hechtia Glomerata	31
Clay	32
Bochmeria Argentea	33
Betula Populifolia, Bark	34
Caladium	35
Cupressus, Bark	36
Adriantum Capillus-Veneris, Maidenhair Fern	37
Hippopus Maculata, Shell	38
Pyrite, Mineral	39
Pholas Costata, Shell	40
Wing of Papilio Blumer, Butterfly	41
Pyrite, Mineral	42
	105

15.
Three spreads from *Patterns from Nature* showing five of the nine photographic patterns that Horst reproduced in the book.

Steichen, Charles Sheeler and others for Mallinson Fabrics' 'Camera Prints' collection of the 1930s. However, Horst appears to have been the first not only to use photo-mosaics for this purpose, but also to publish his designs alongside the images from which they were created, suggesting their wider design application. As historian Dilys Blum has pointed out, the demand for artist-designed textiles grew after the Second World War for several reasons, including the willingness of artists, galleries and the textile industry to work together to revitalize their market in the face of renewed French competition; the continuation of government wartime fabric restrictions resulting in unadorned dresses where the pattern made the fashion; and a greater aesthetic awareness in the American people, generated by the public-art programmes of the Works Progress Administration.[23] Horst's foray into photography's potential overlap with textile design was part of a wider movement to make such endeavours possible. Yet it also neatly dovetailed with his personal interests and professional experience.

During his working life Horst maintained a personal archive, which remains intact to this day. It contains prints, negatives, magazines, books, scrapbooks, personal ephemera and props used in his photographs. A recent search of this archive uncovered a further twenty-six collaged designs, none of which were reproduced in *Patterns from Nature*. This gives a total of thirty-seven known designs, which are gathered together in the present volume for the very first time. In the few instances where the original collage is in poor condition or has a piece missing, it has been possible to reconstruct the full pattern digitally by following Horst's formulas for a simple repeat. When considering the design of this book, it seemed fitting to embrace one of Horst's suggested uses for his patterns and apply one each to the dust jacket and the cover.

This set of Horst's innovative images reveals their inherent beauty as photographic objects in their own right. It also unlocks their forgotten potential as inspirations for design. Surely, this would have pleased Horst, who made so clear the wide-ranging and collaborative aspirations that he had for his photographs.

17

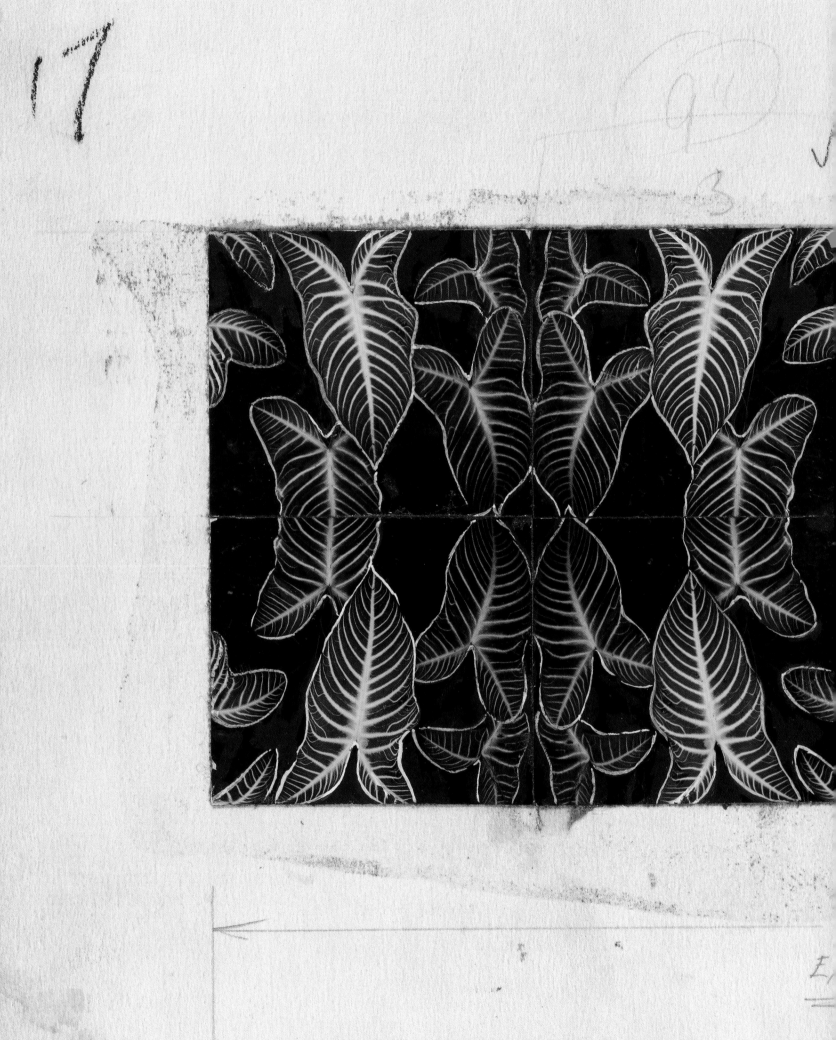

REVERSE COLOR

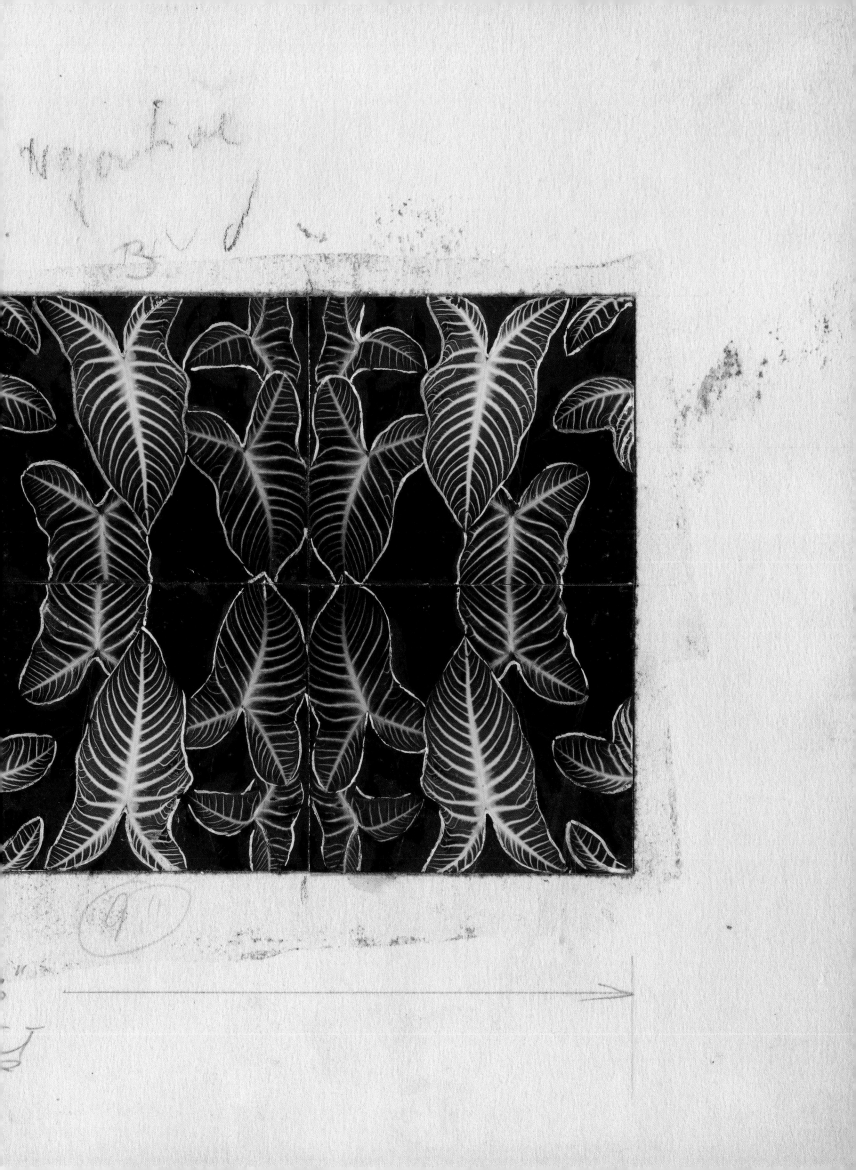

Plates

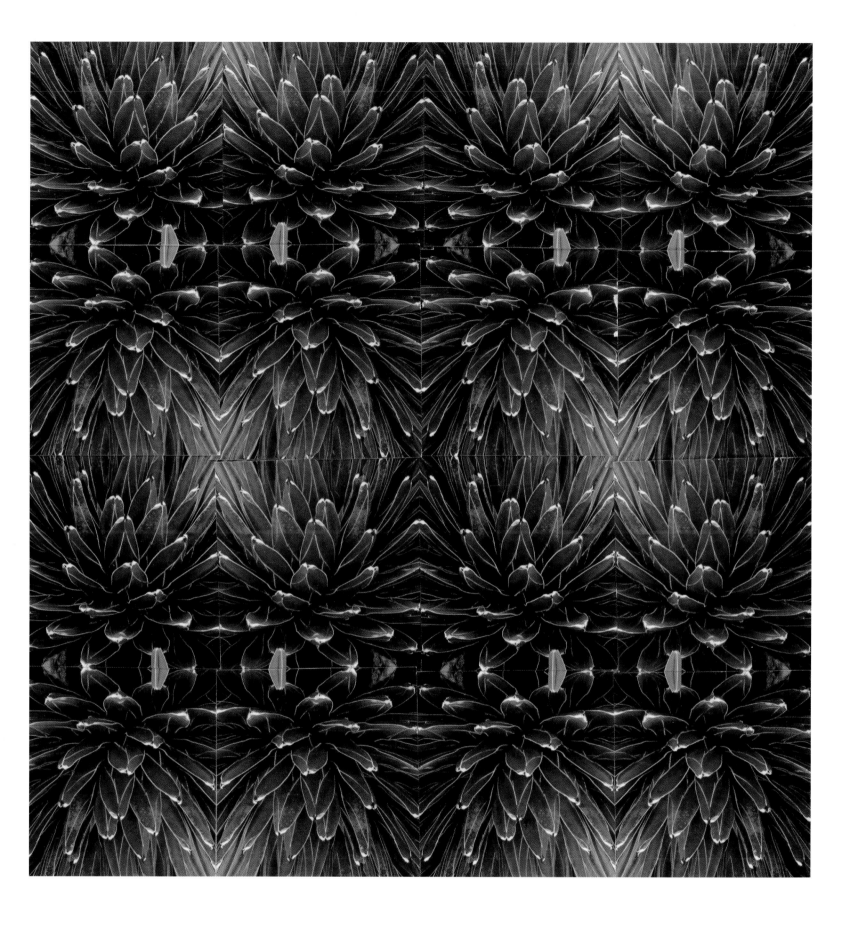

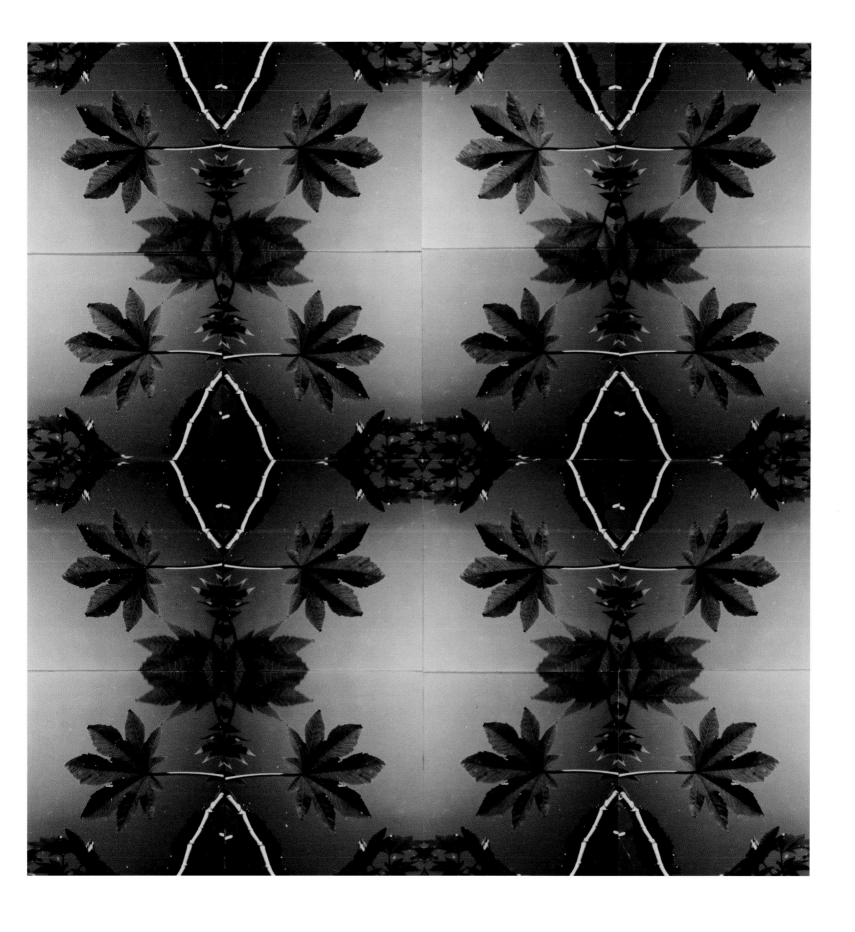

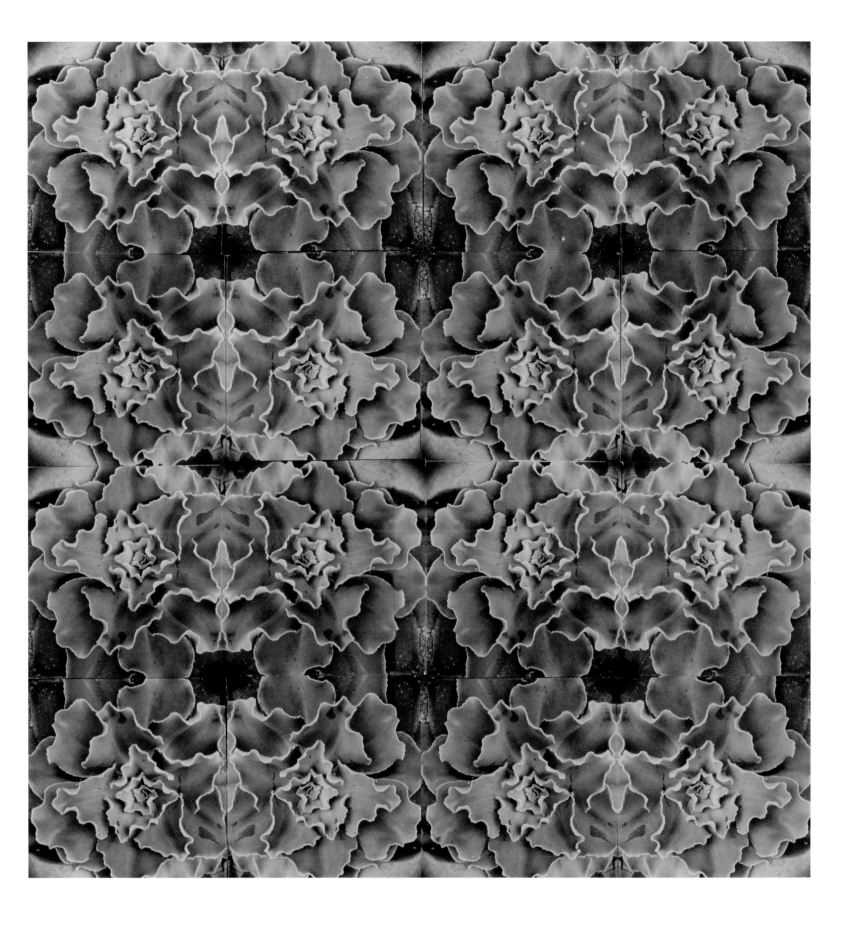

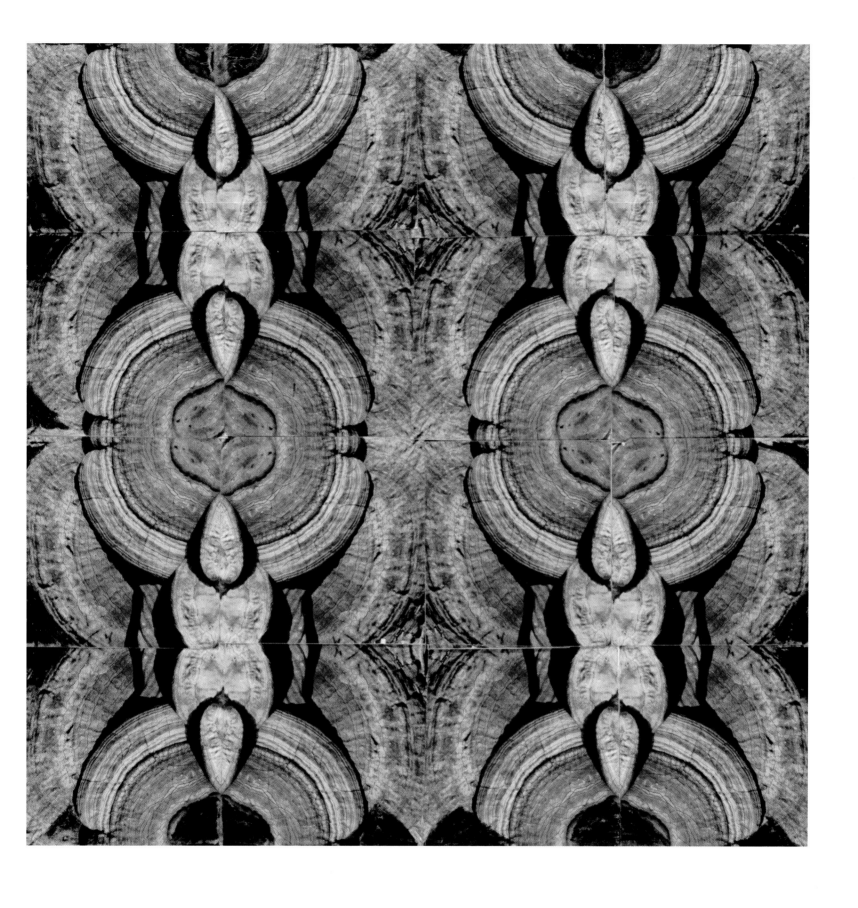

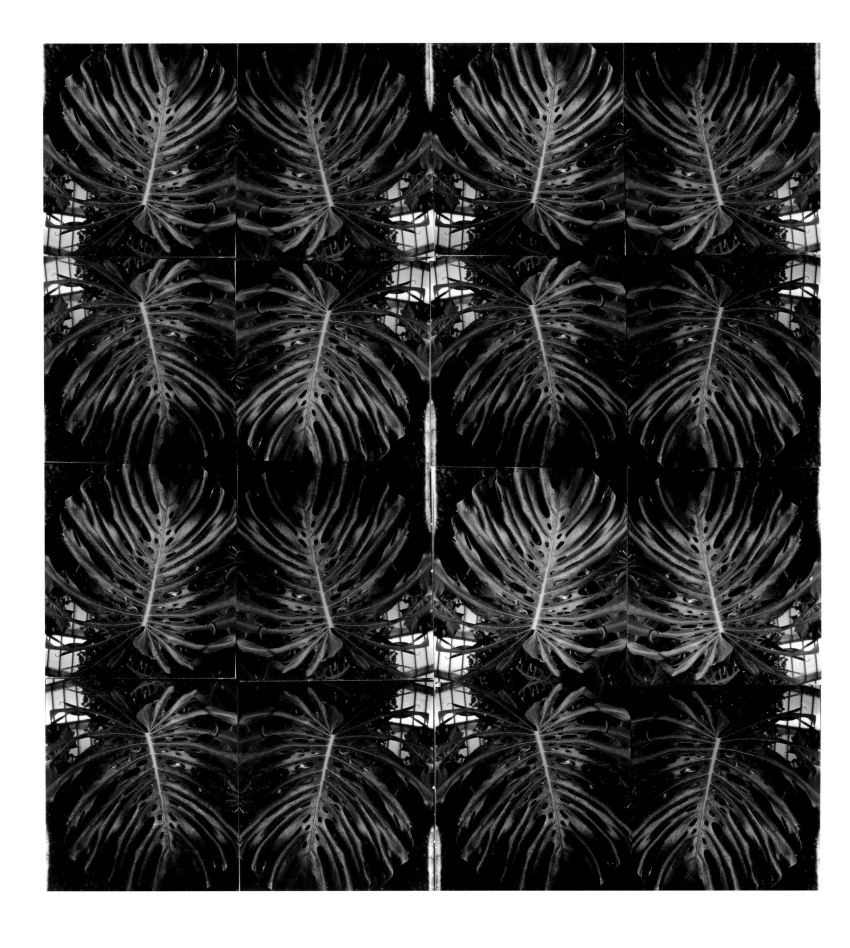

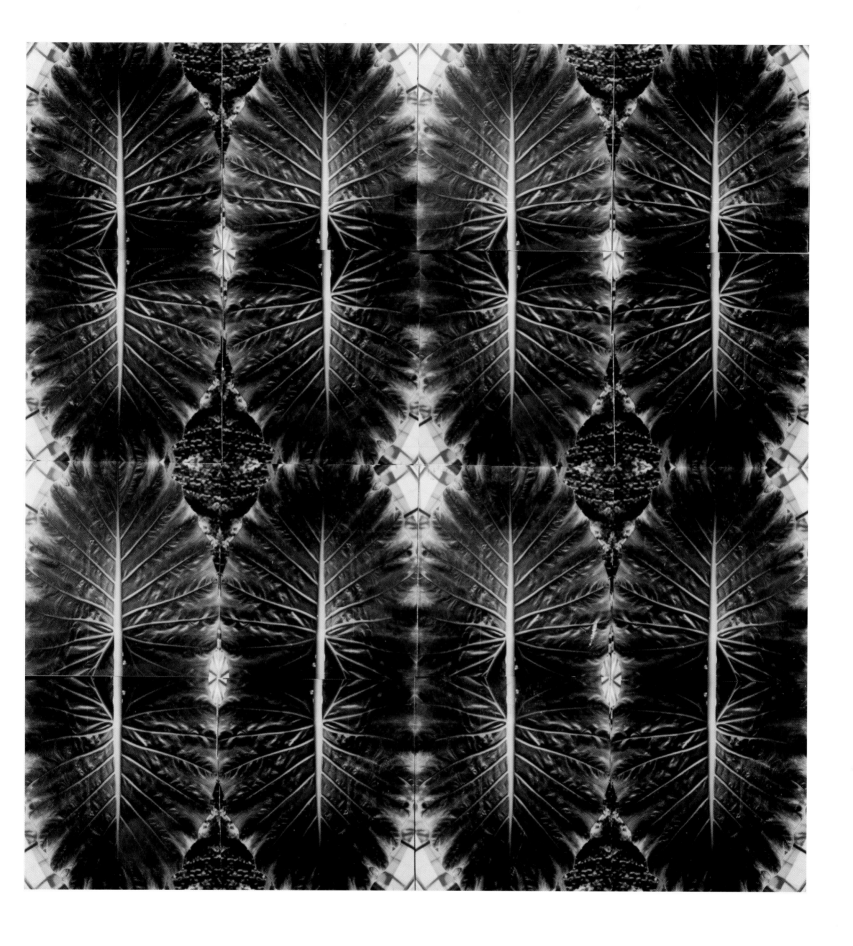

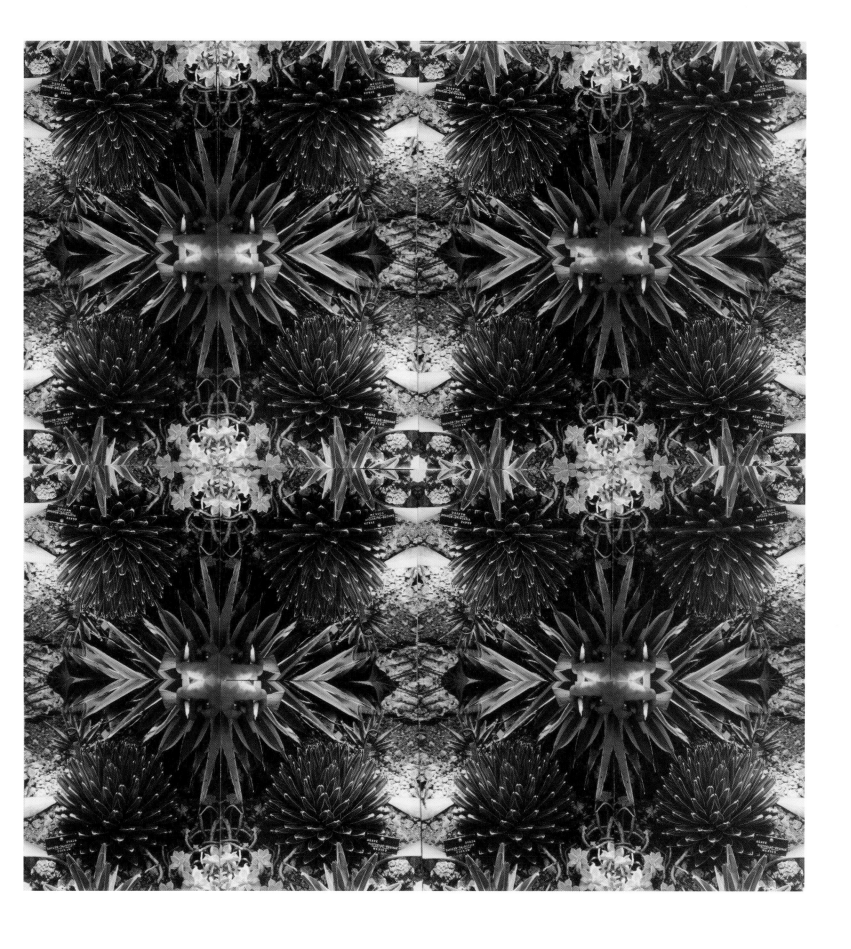

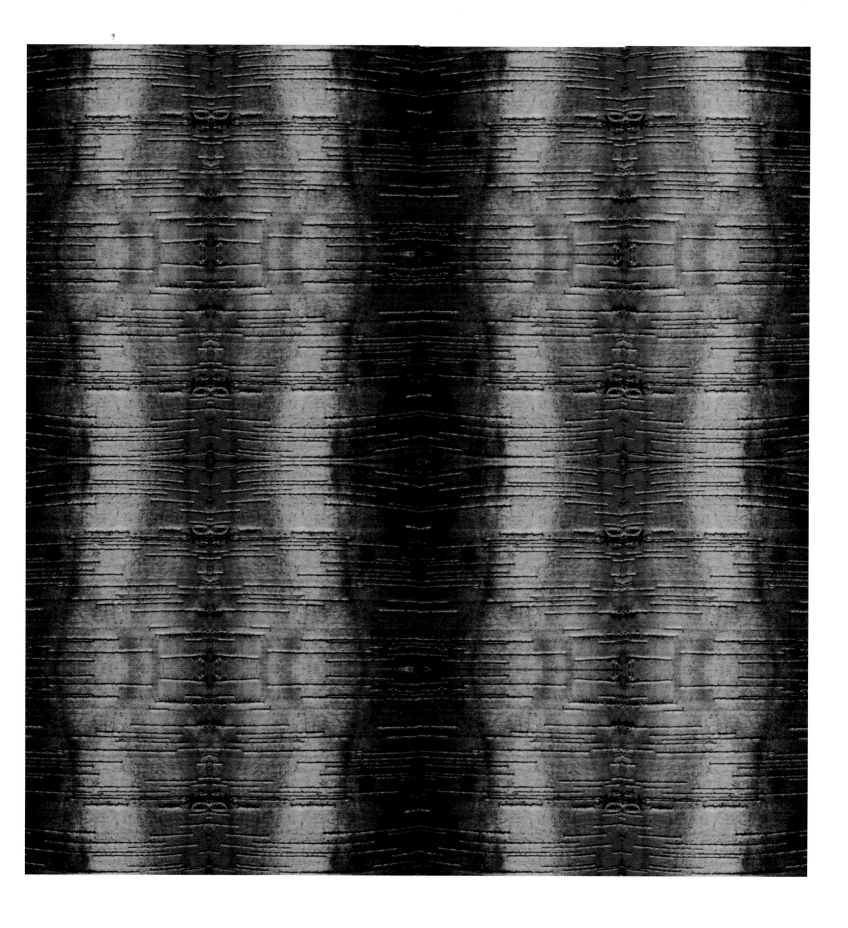

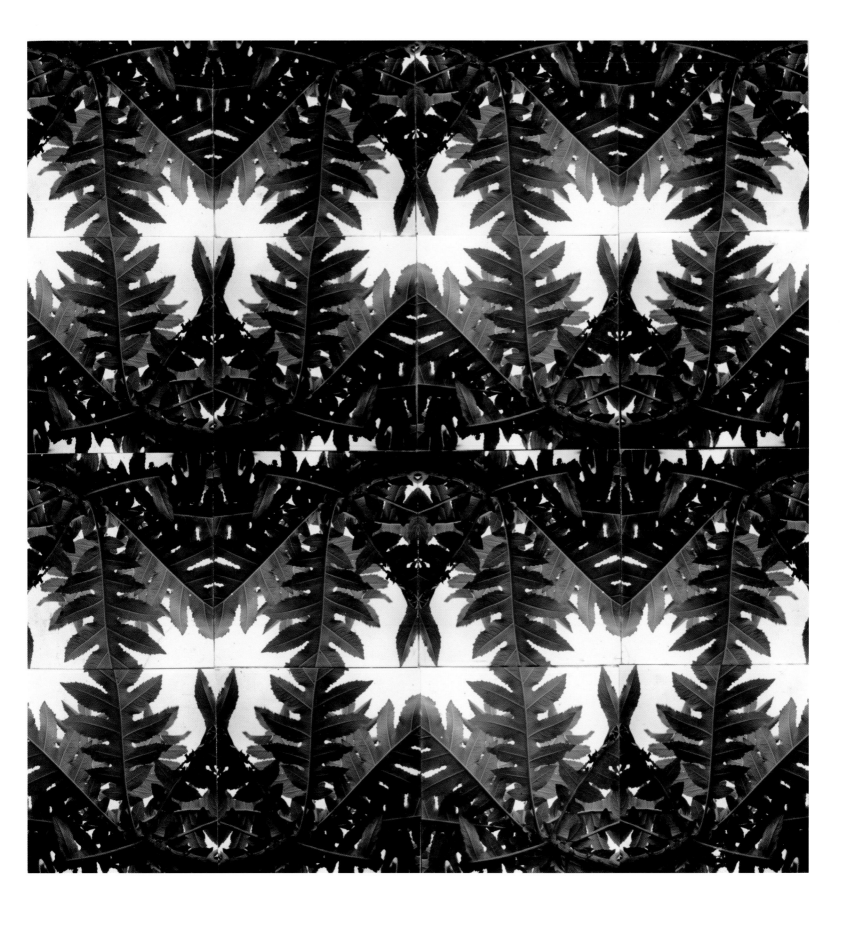

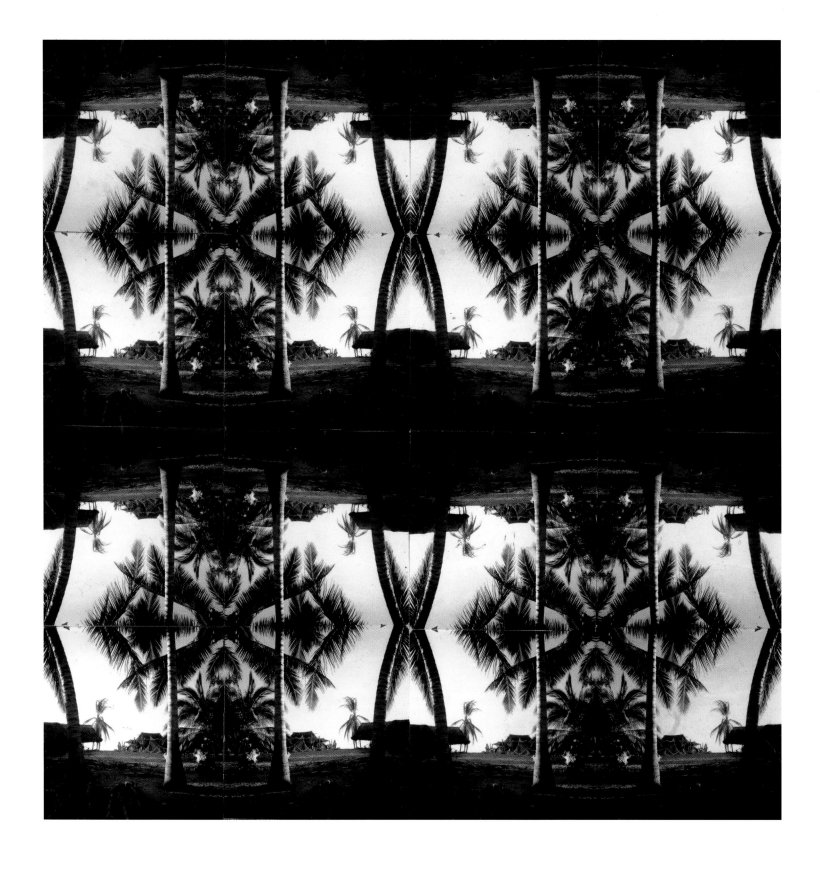

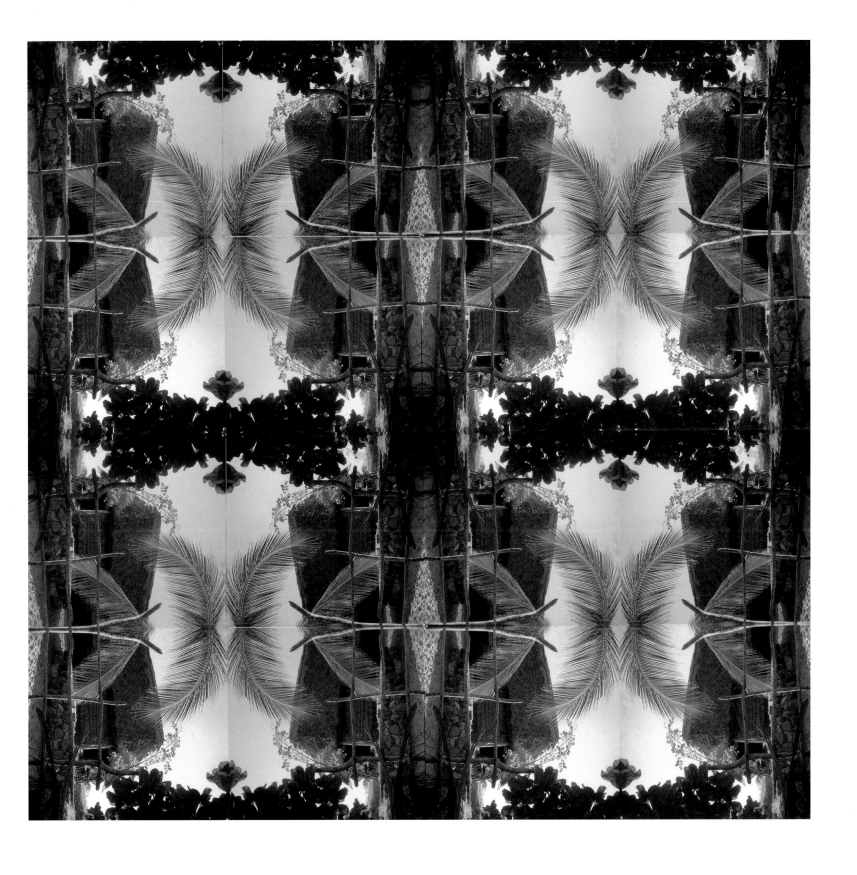

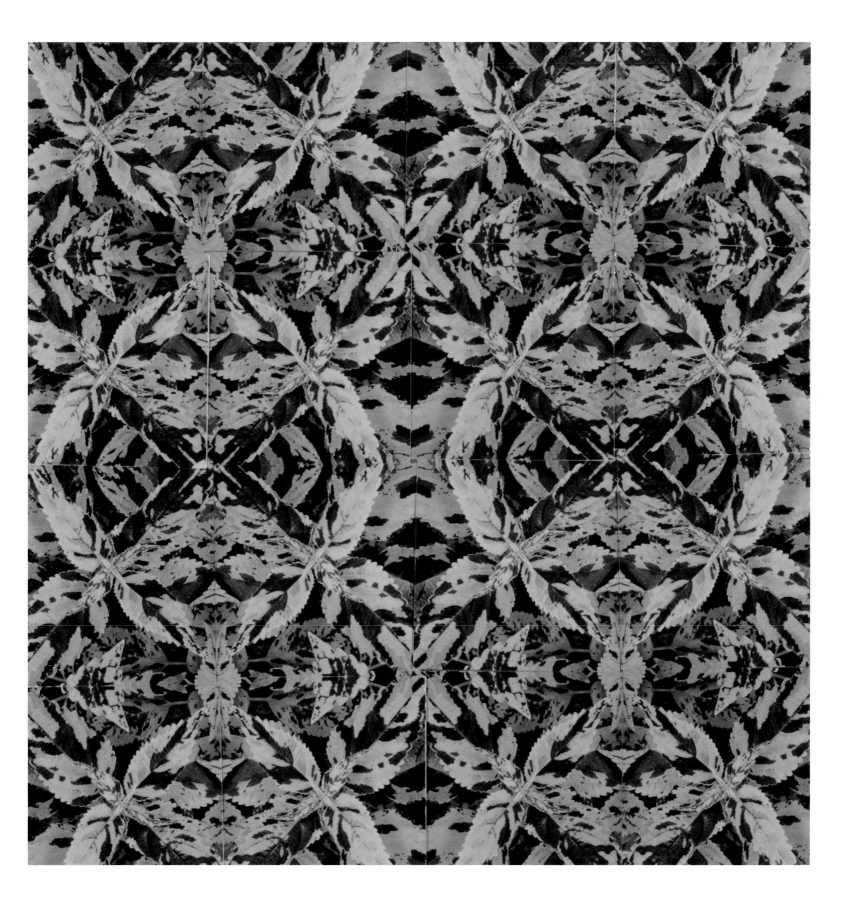

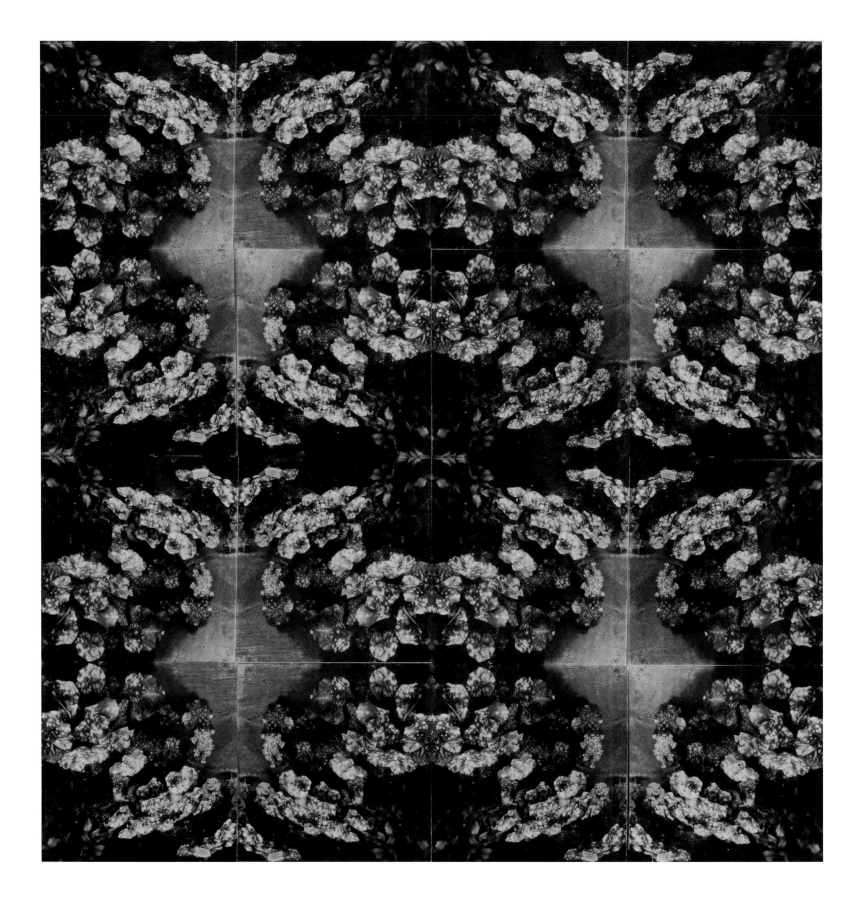

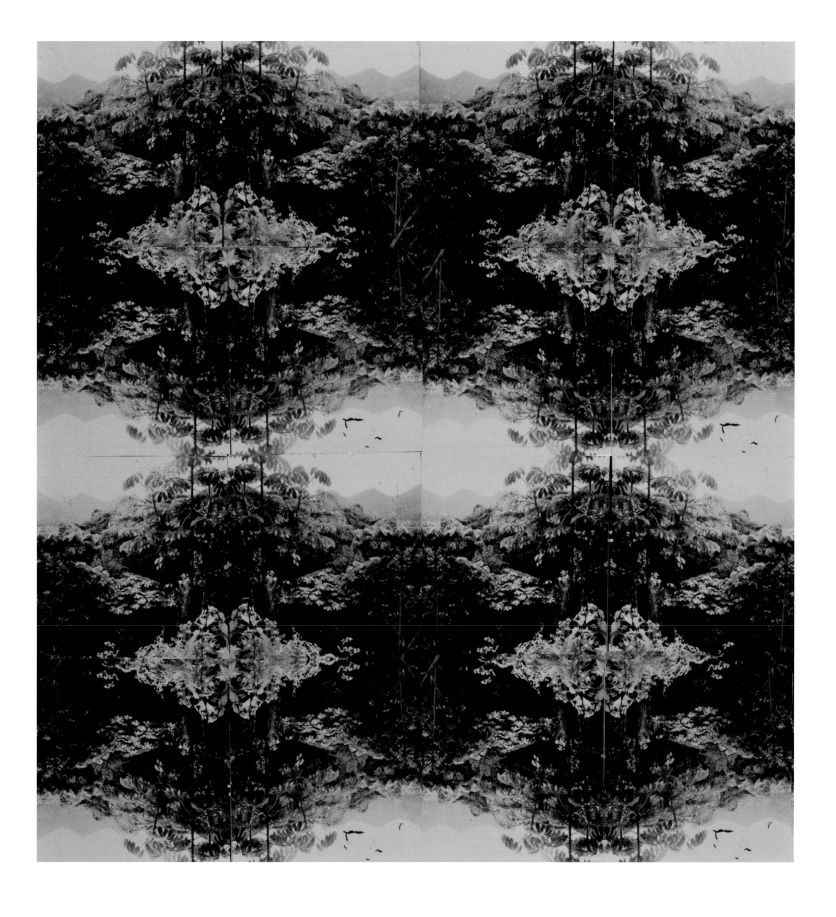

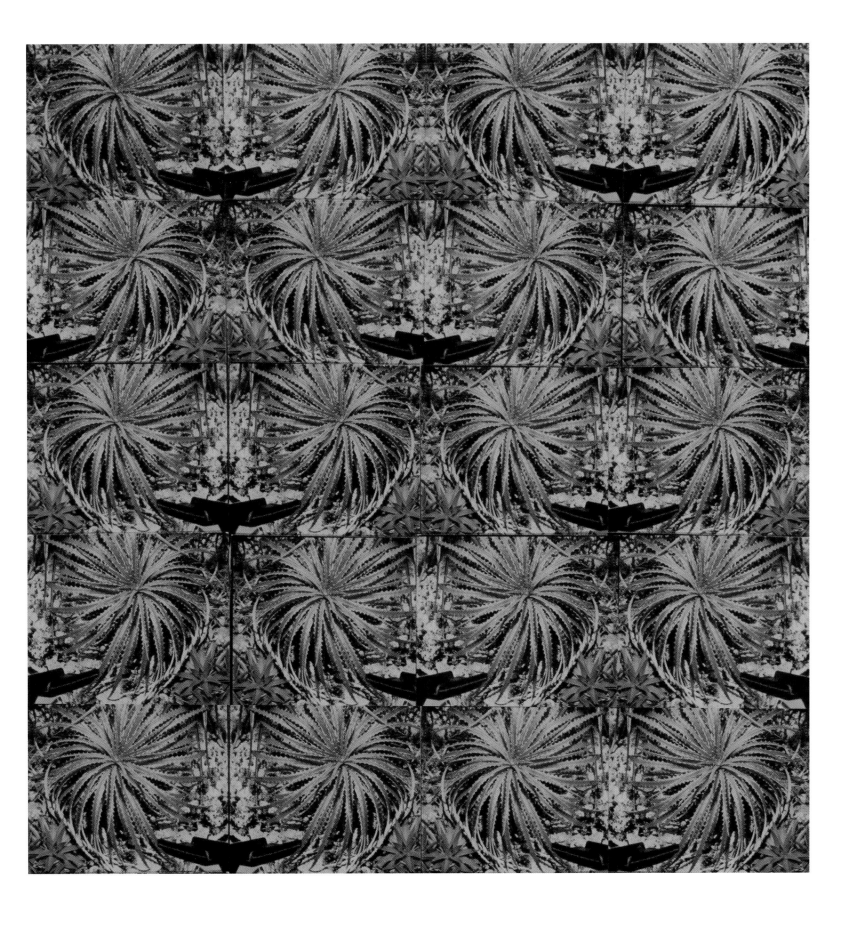

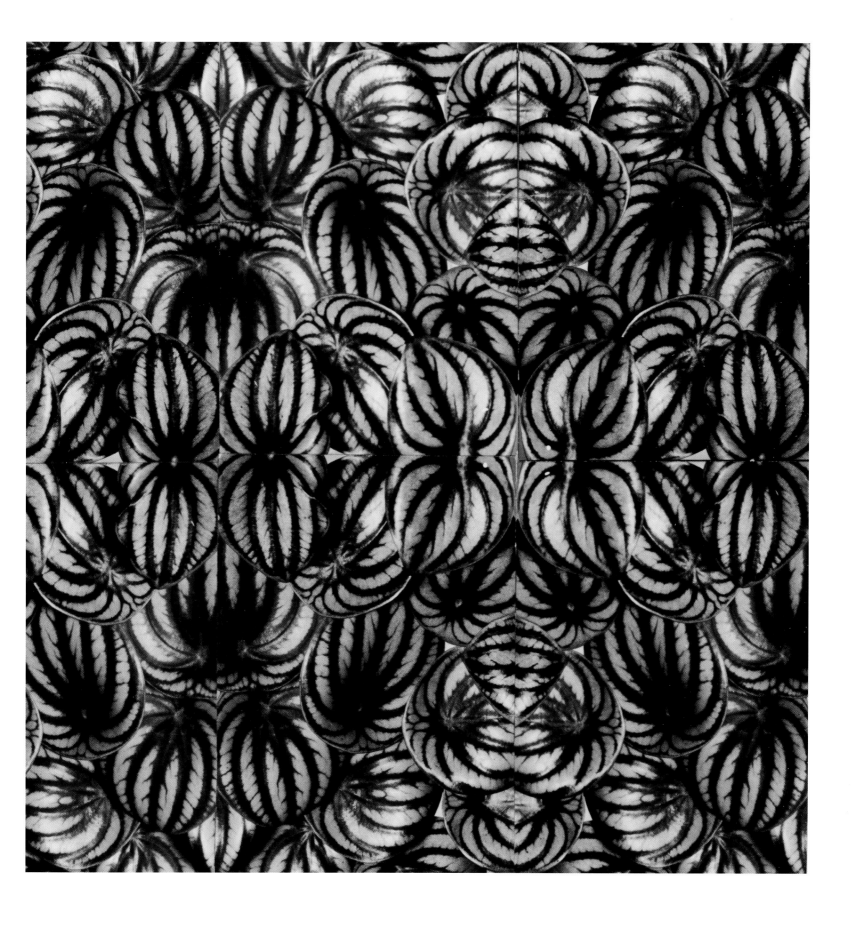

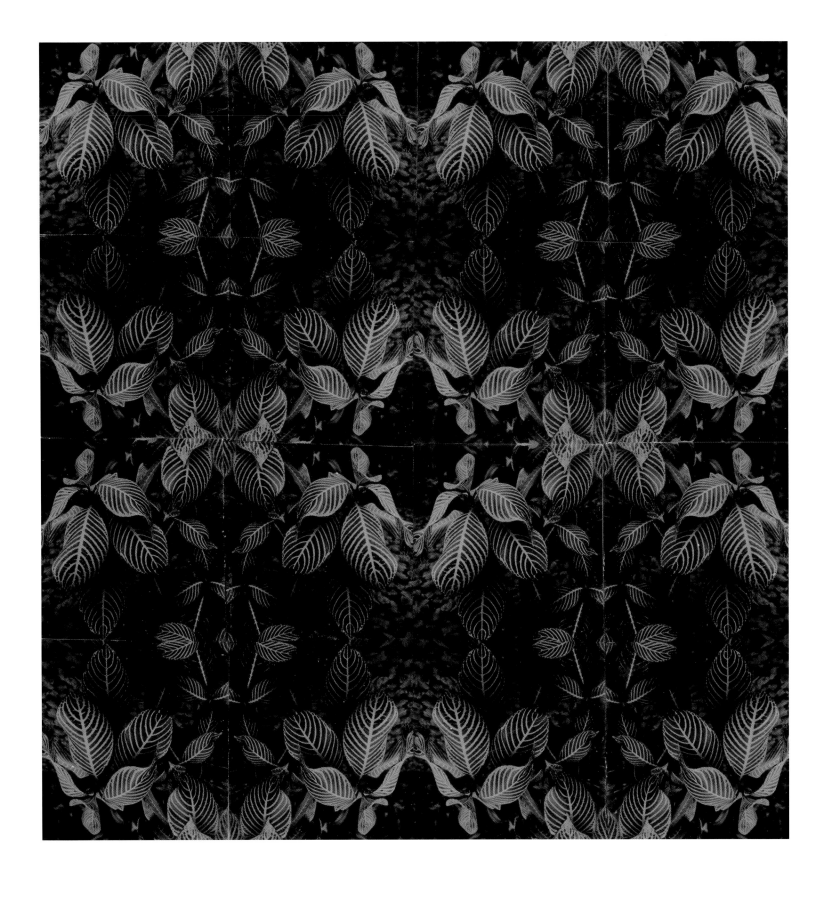

64

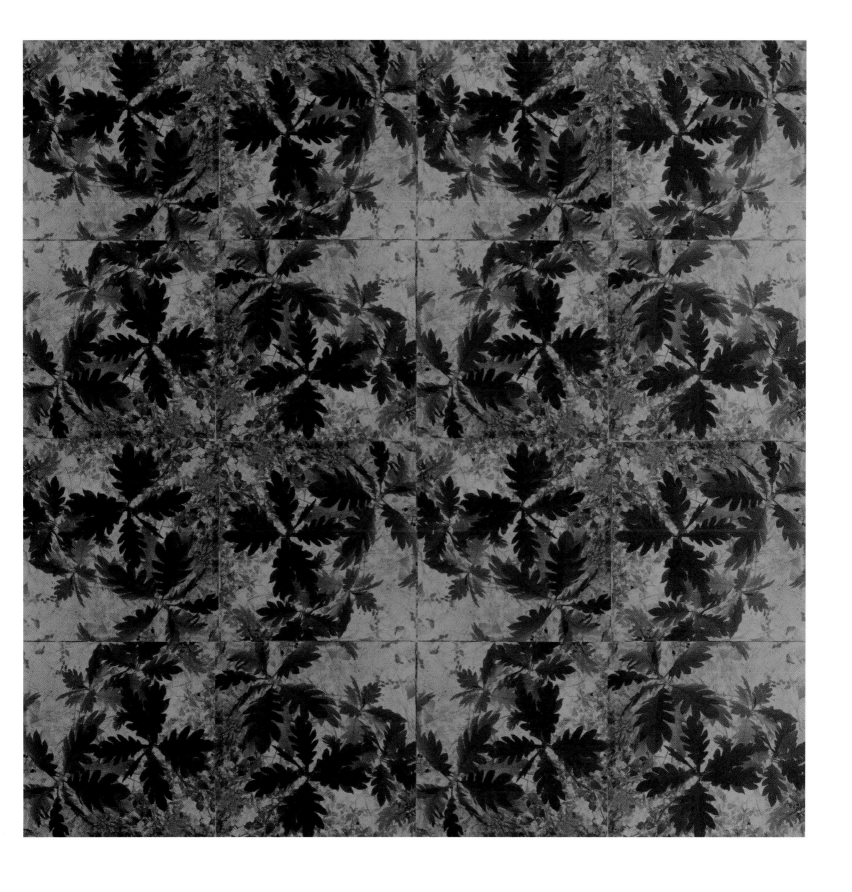

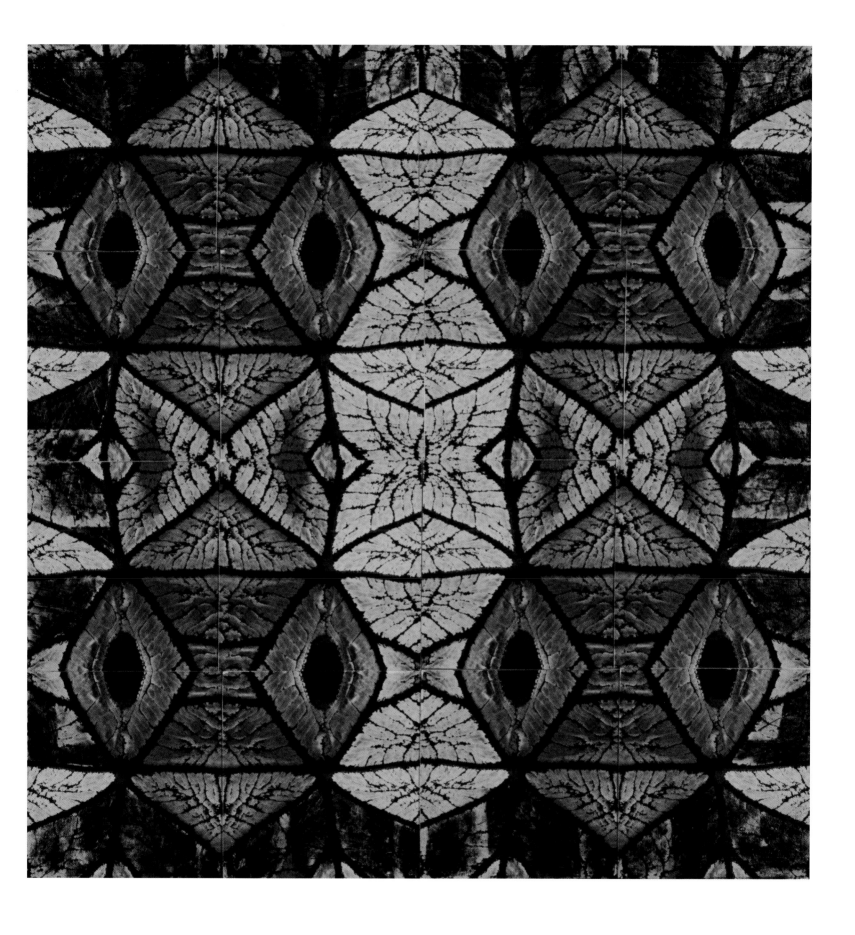

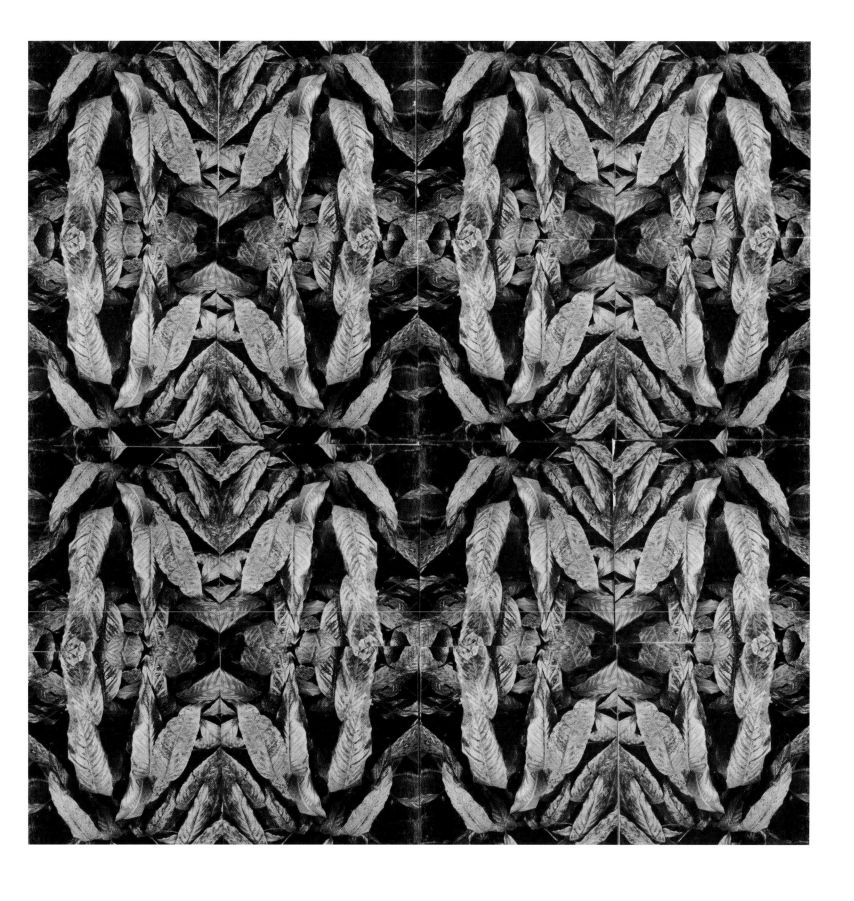

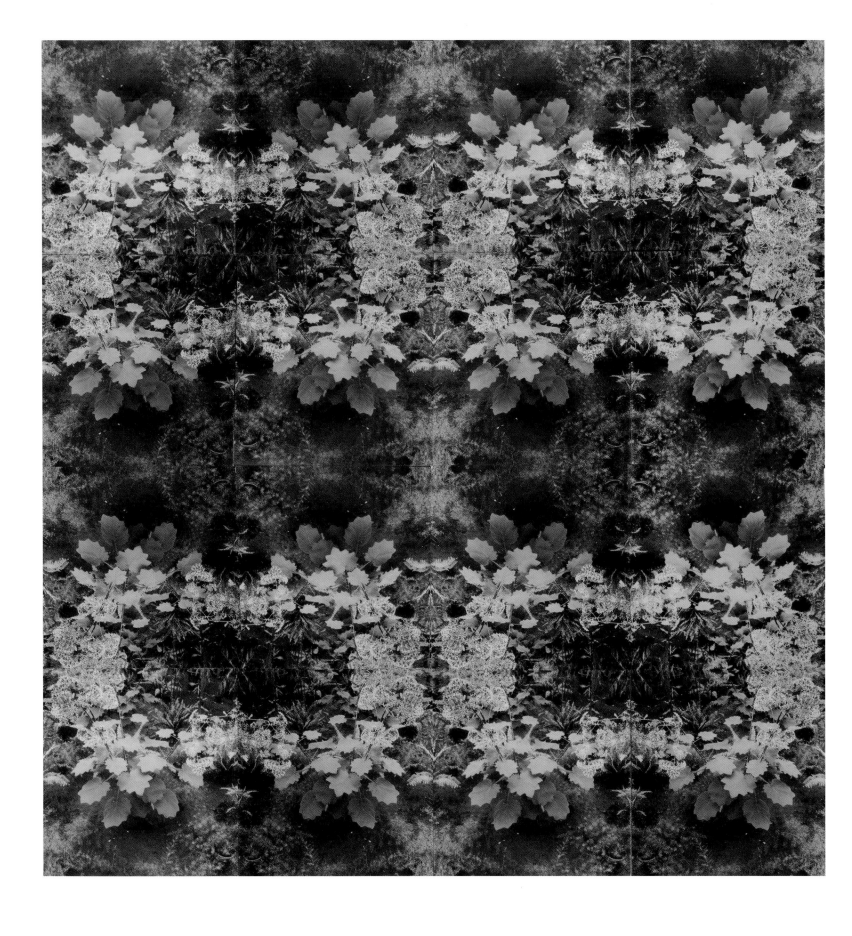

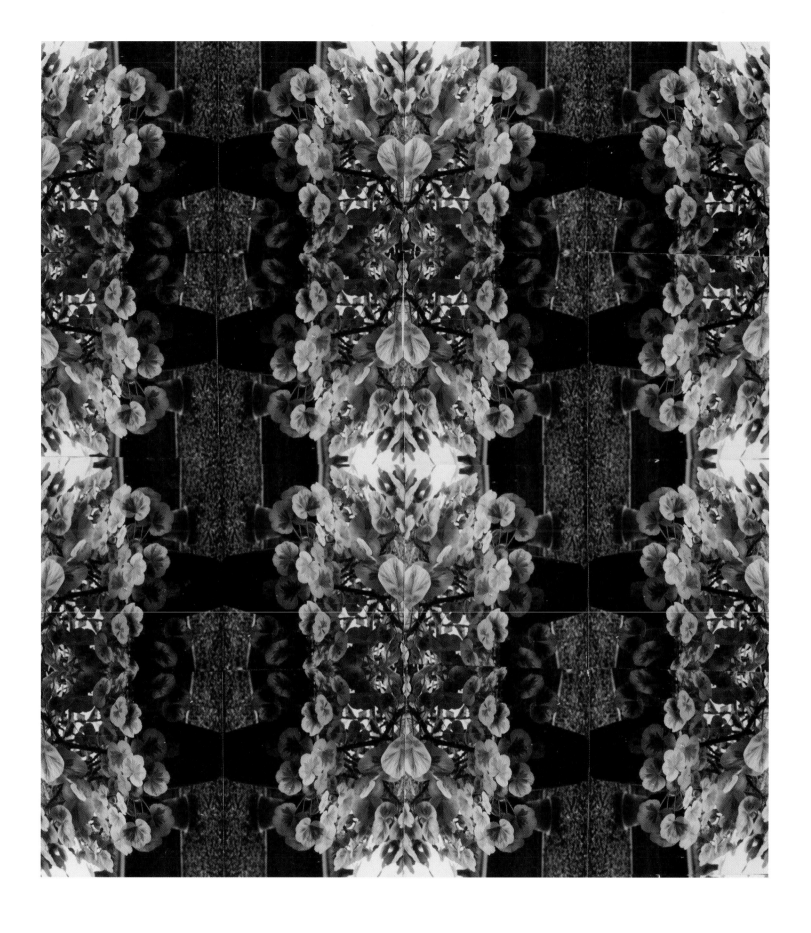

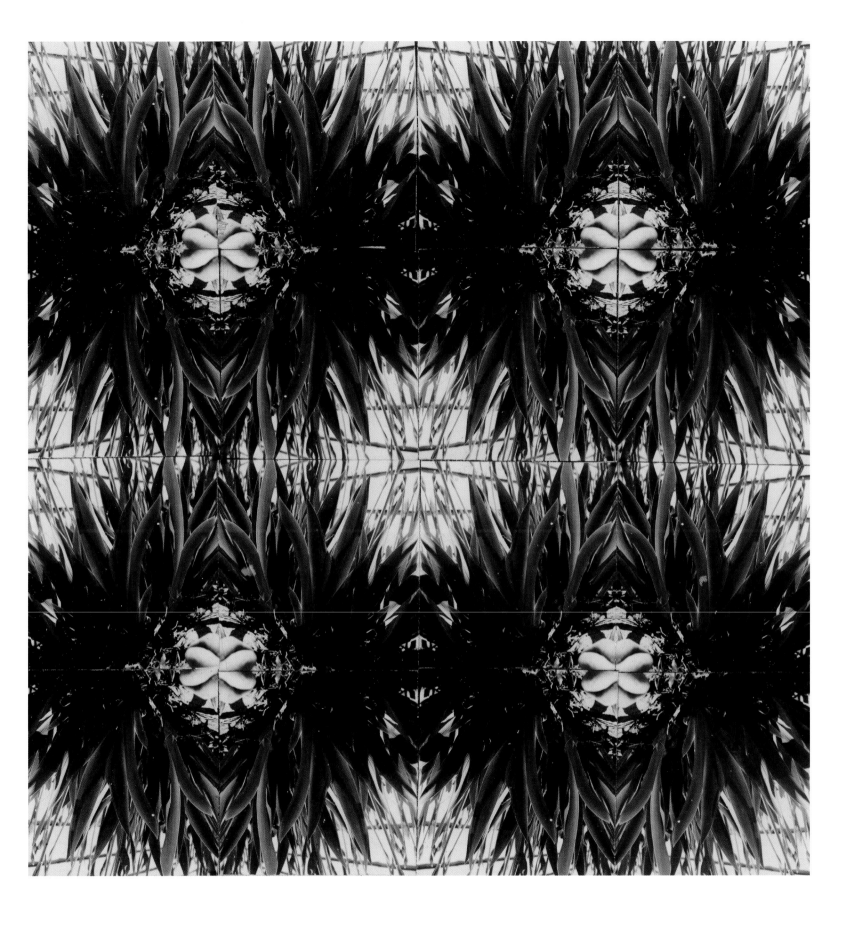

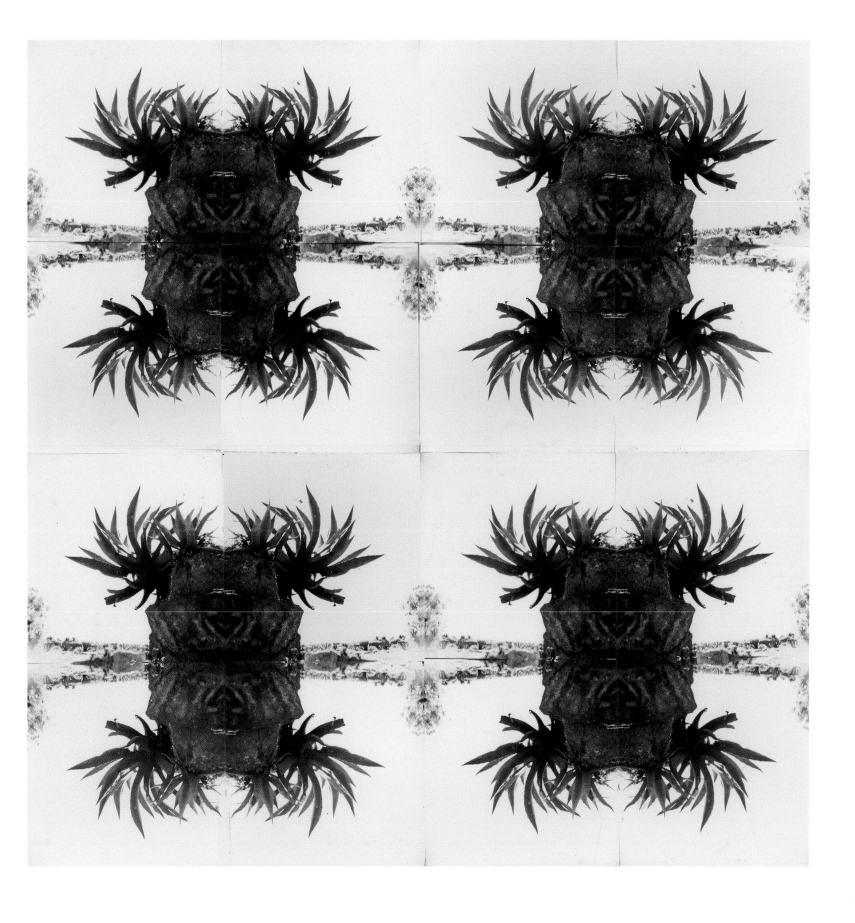

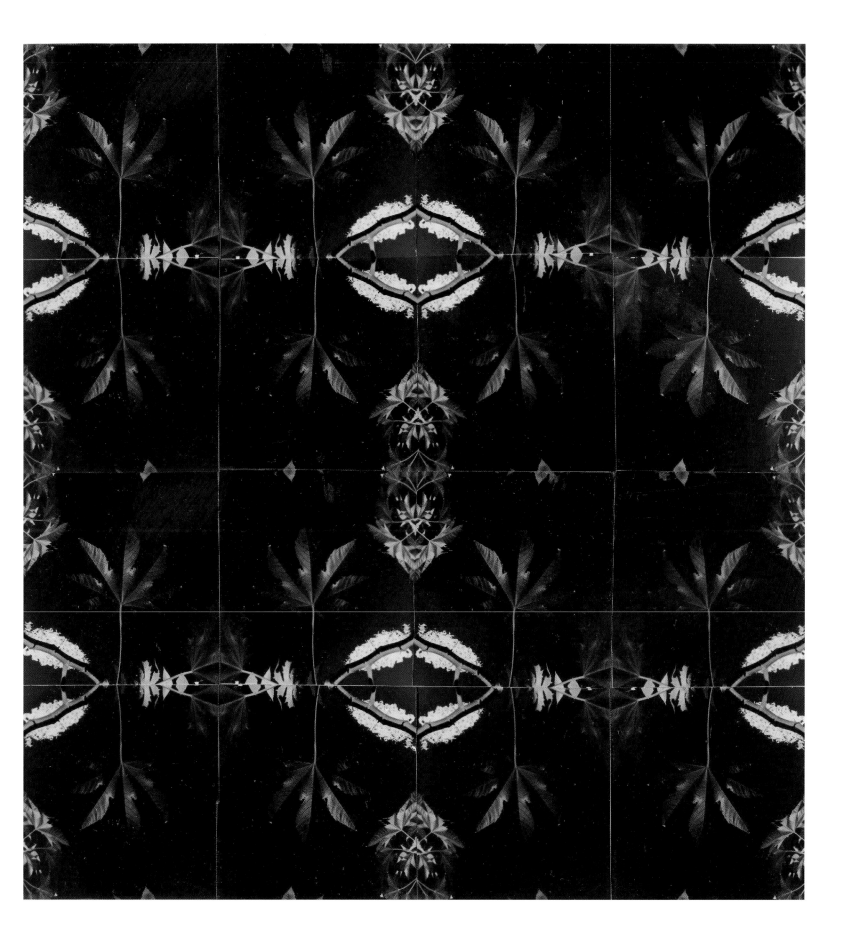

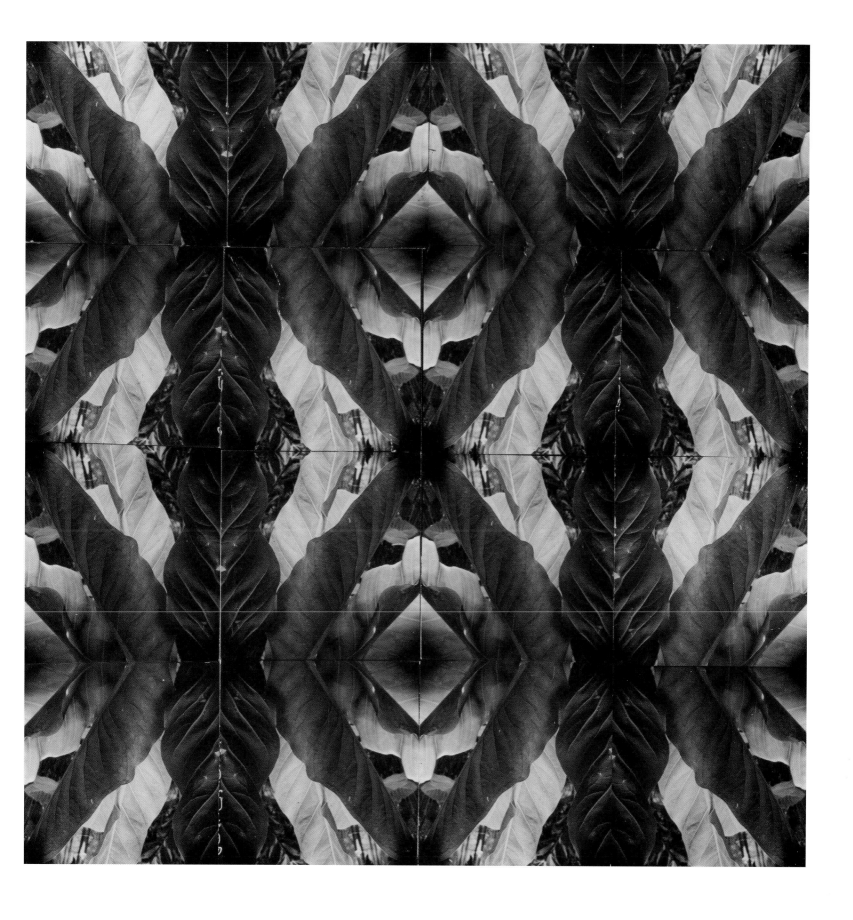

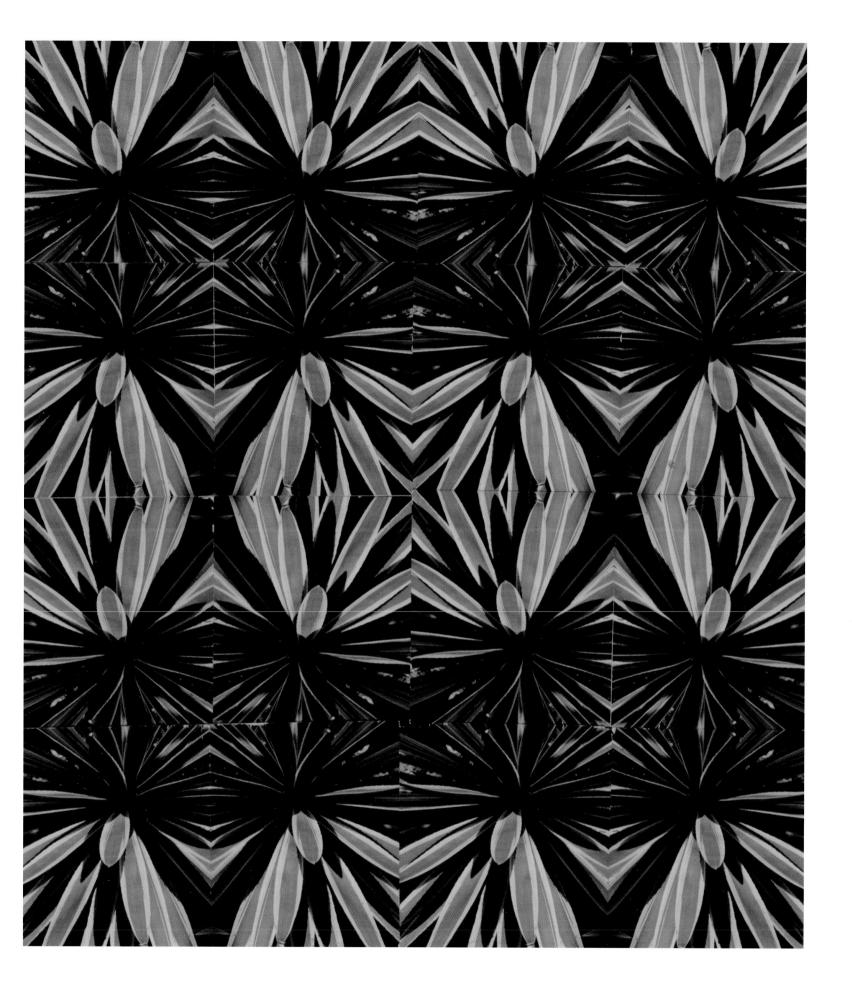

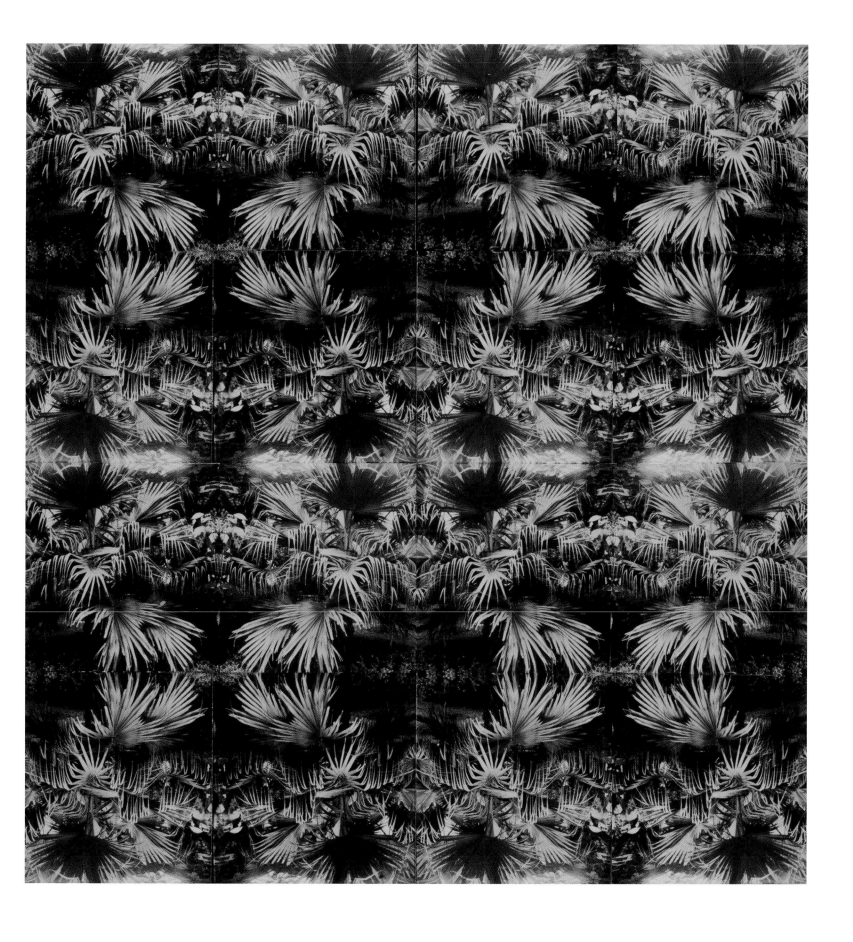

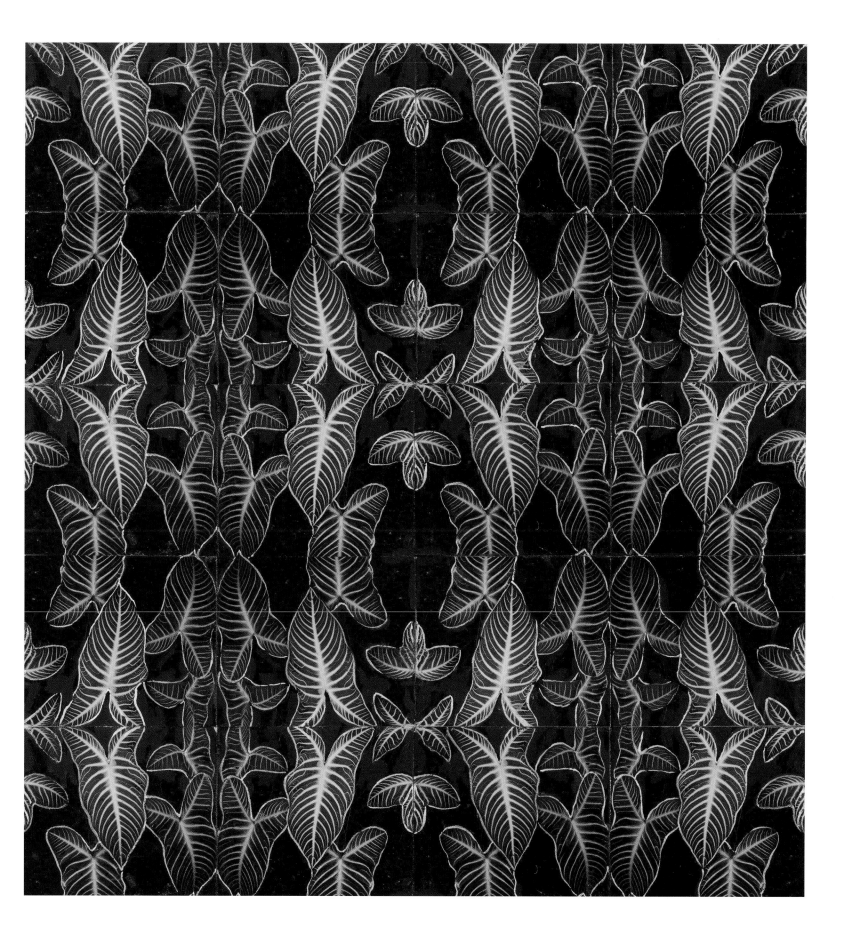

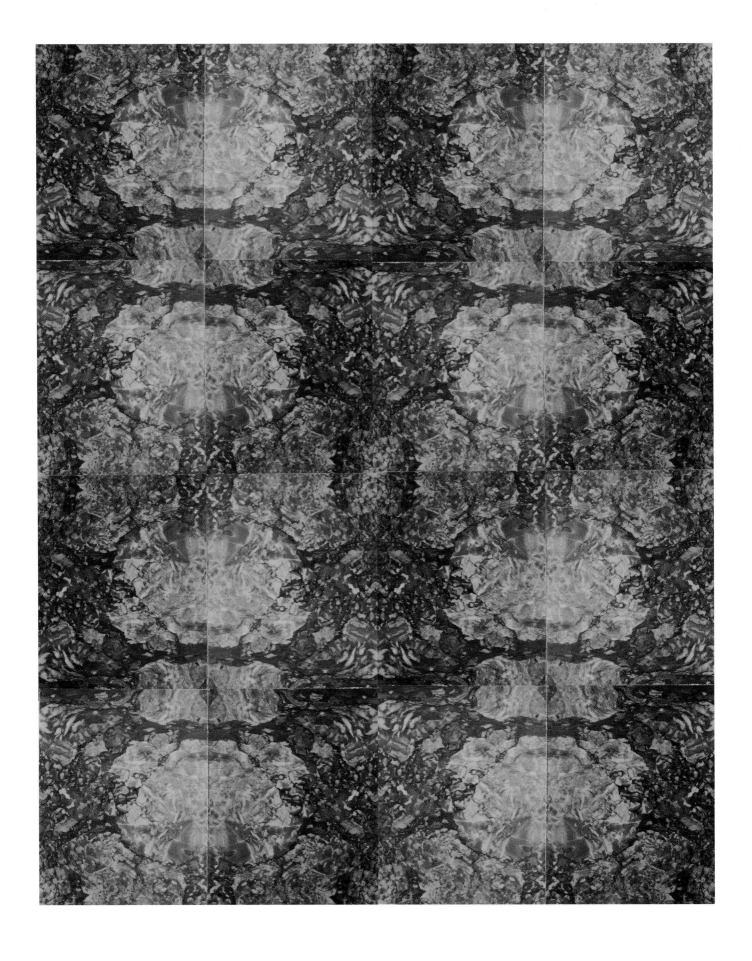

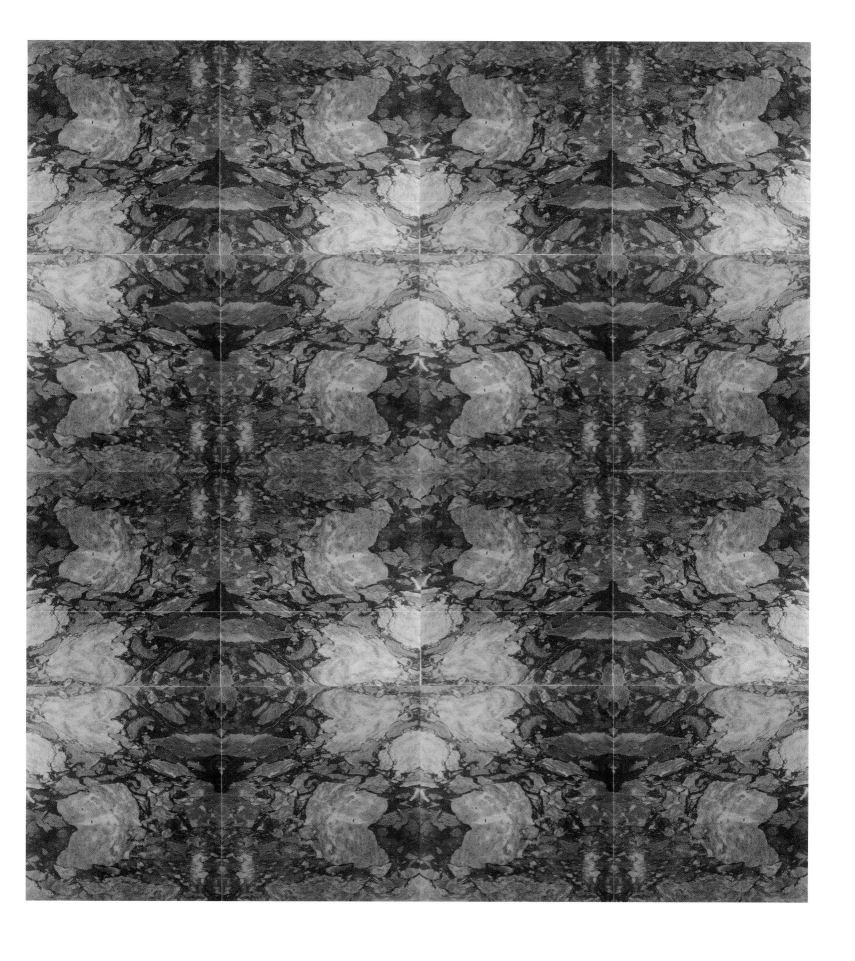

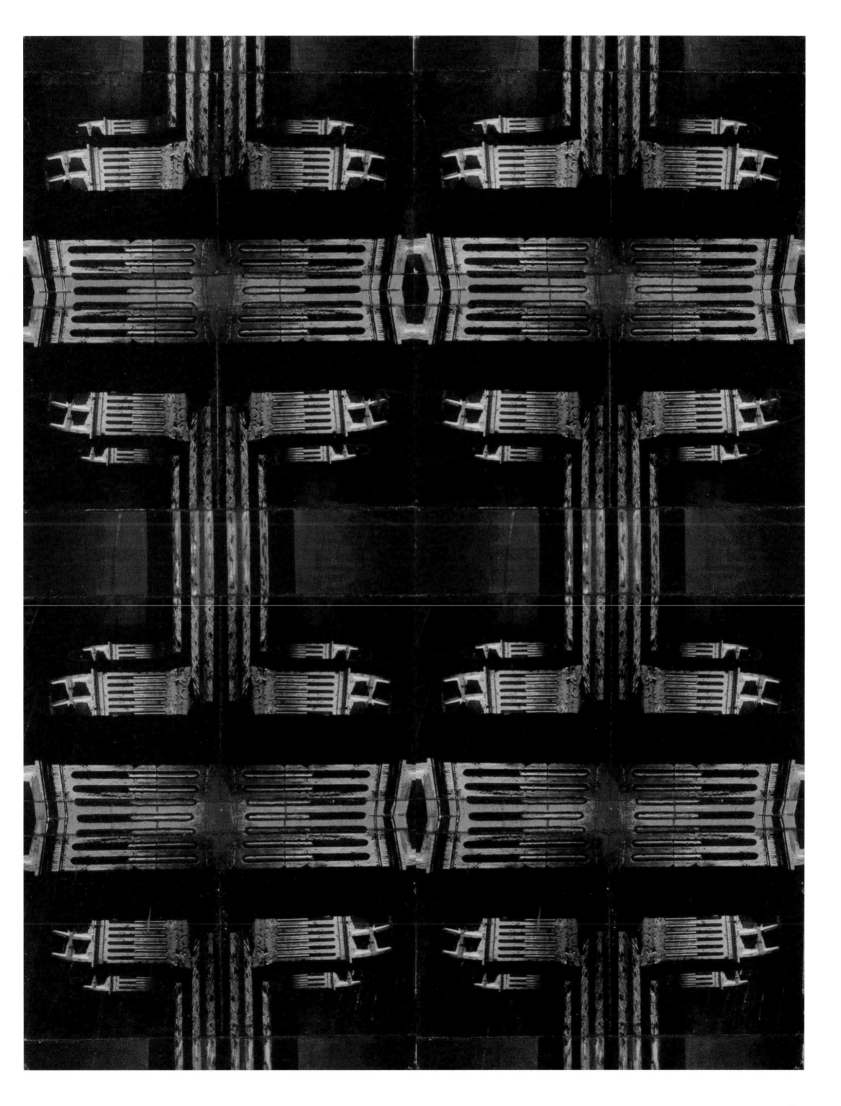

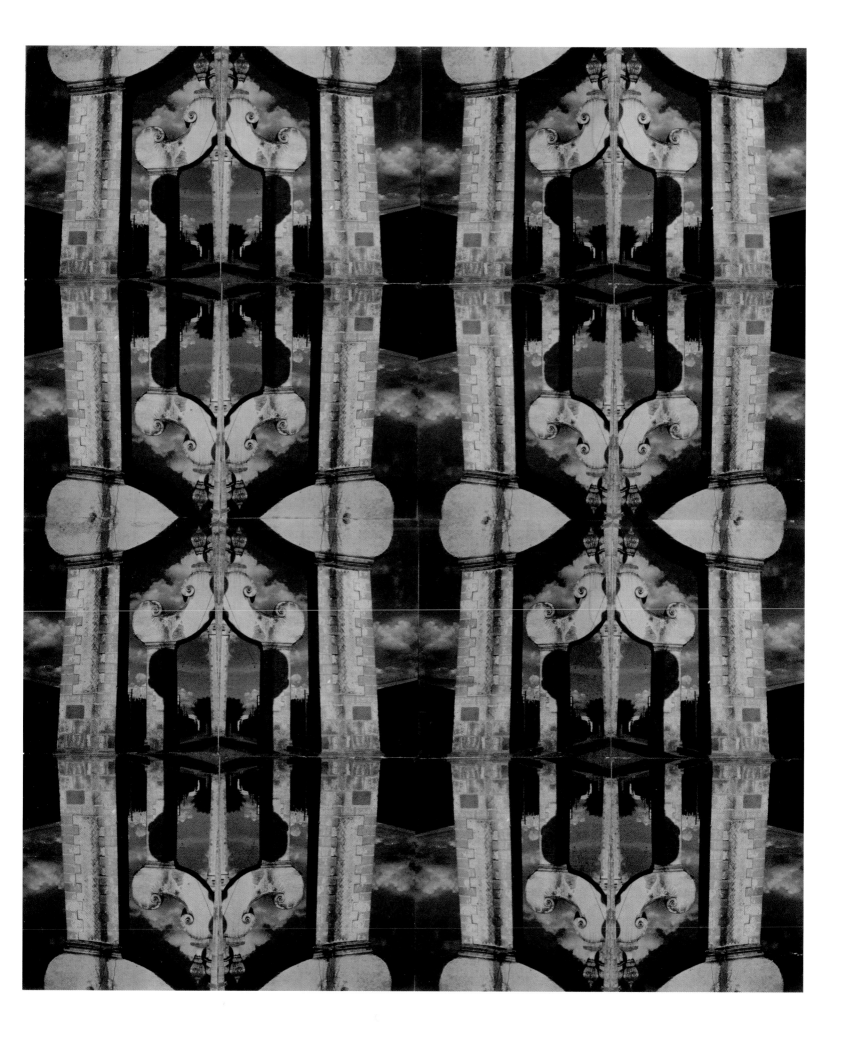

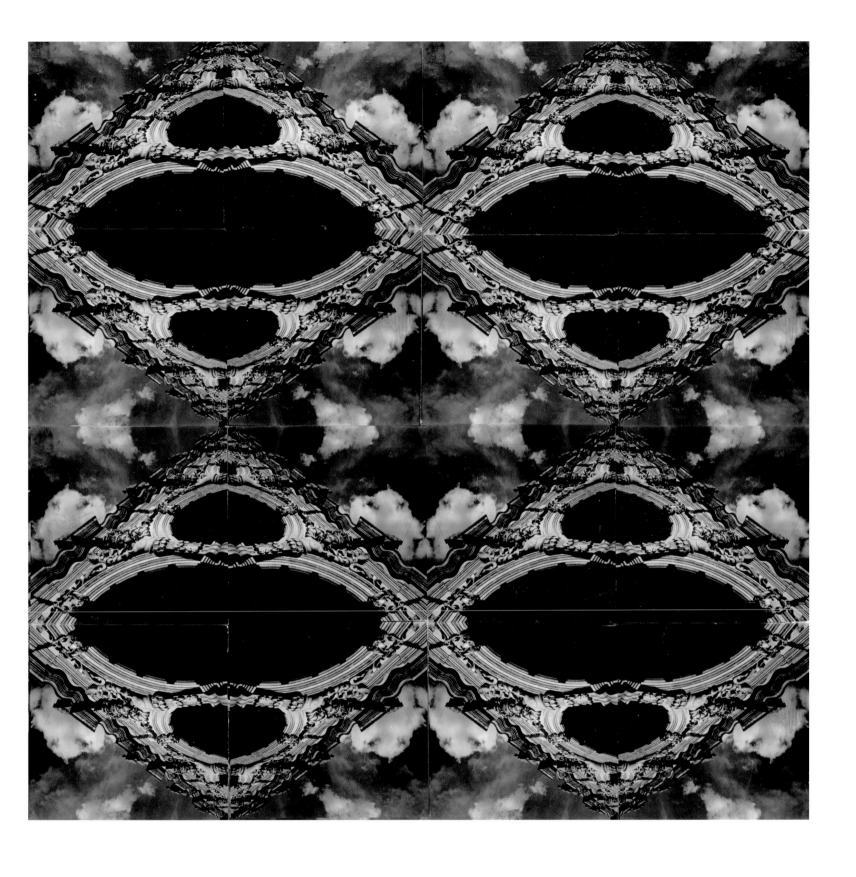

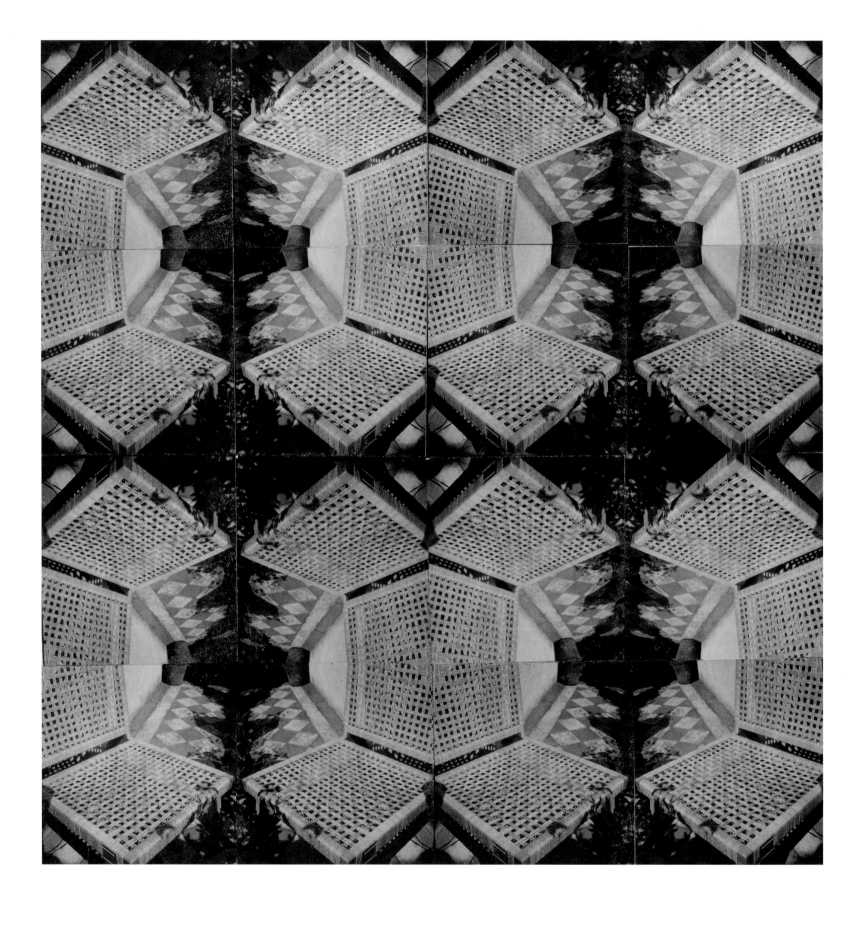

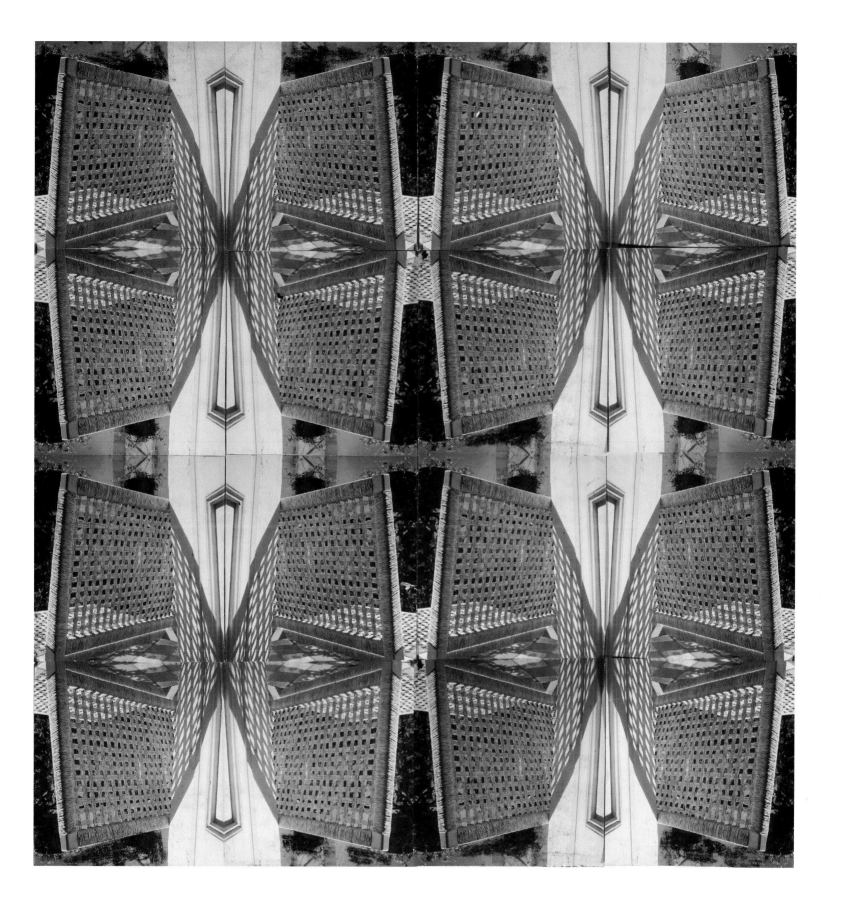

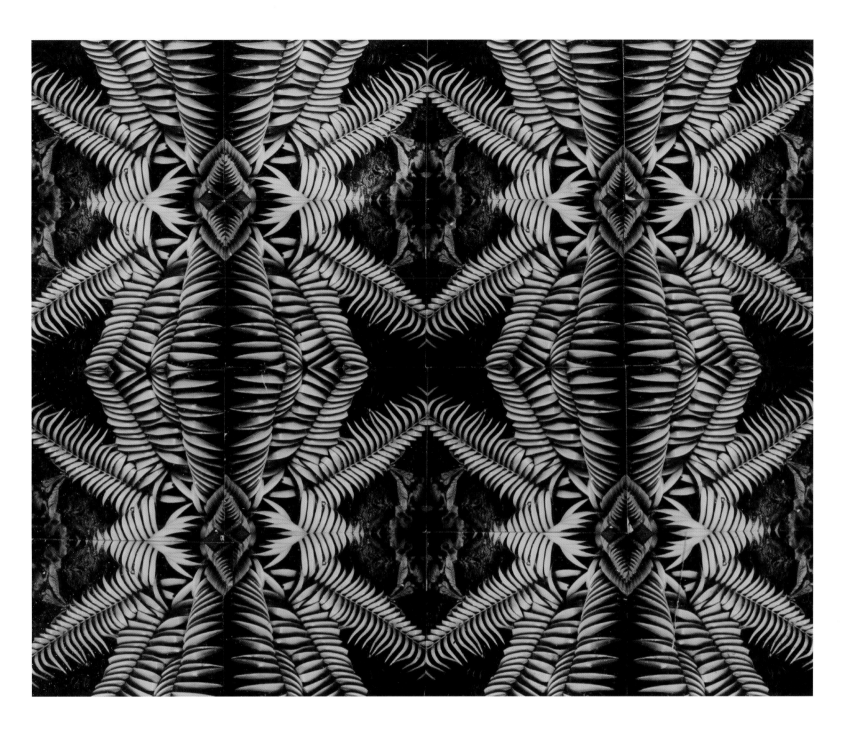

List of Plates

Horst titled each of the nine collages he reproduced in *Patterns from Nature* simply *Photographic Pattern*. However, he also referred, by page number, to the single images in the book from which the patterns were derived. Some of these images are accompanied by the Latin or common name of the specimen that forms the subject of the photograph, while others are labelled 'Unidentified'. The following list of plates is an adaptation of this convention, with the subject of the source image (where known) appearing in parentheses. It should be noted that the Latin names follow the spelling and capitalization adopted by Horst, both of which occasionally differ from modern usage.

Horst signed a few of the patterns (see, for example, the frontispiece and page 26), indicating a preferred orientation for the work. However, in *Patterns from Nature*, some of them were reproduced in differing orientations. Horst envisaged his patterns being used for decorative purposes; in the present publication, this has suggested a degree of creative licence when deciding on the orientation of an image, when this was not clear from a signature or annotations. Black pencil and white inks were used on the original collages to tidy up borders and joins, and to enhance the contrast, probably for the purposes of re-photographing them for publication; in the same spirit, some digital re-touching has been carried out to the images reproduced in the plate section of this book. For the sake of consistency, some of the patterns have also been increased in size to create a larger repeat than is evident in the original.

All the original photographic patterns are held in the archive of the Horst Estate, Miami, with the exception of those reproduced on pages 39 and 91, which are in the collection of the New York Public Library (Wesley Simpson Custom Fabrics, Inc. Swatch Book Archive, 1898–1950, call no. JSN 08-2). The nine photographic patterns that appeared in *Patterns from Nature* are those reproduced on pages 39, 45, 51, 57, 63, 67, 69, 81 and 97 of the present volume. The original collages range in size from 28.7 × 23 cm (11¼ × 9 in.) to 35.2 × 27.9 cm (13¾ × 11 in.).

Page

39 Photographic Pattern (Agave, Victoria Regina)

41 Photographic Pattern (Unidentified)

43 Photographic Pattern (Echevenia Gibbiflora Crispa)

45 Photographic Pattern (Bracket Fungus)

46 Photographic Pattern (Unidentified)

47 Photographic Pattern (Unidentified) [original annotated 'wallpaper']

49 Photographic Pattern (Unidentified)

51 Photographic Pattern (Prunus Pennsylvania Bark)

53 Photographic Pattern (Unidentified)

54 Photographic Pattern (Palm Trees)

55 Photographic Pattern (Palm Trees)

57 Photographic Pattern (Coleus Blumei)

58 Photographic Pattern (Unidentified)

59 Photographic Pattern (Unidentified) [original annotated 'wallpaper']

61 Photographic Pattern (Unidentified)

63 Photographic Pattern (Peperomia Sandersii) [original annotated 'silk']

64 Photographic Pattern (Unidentified)

65 Photographic Pattern (Unidentified)

67 Photographic Pattern (Calladium)

69 Photographic Pattern (Spathipyllum Wallisi) [original annotated 'wallpaper']

70 Photographic Pattern (Unidentified)

71 Photographic Pattern (Unidentified)

73 Photographic Pattern (Unidentified) [original annotated 'scarf']

75 Photographic Pattern (Unidentified)

77 Photographic Pattern (Unidentified)

79 Photographic Pattern (Unidentified)

81 Photographic Pattern (Agave Rupicola)

83 Photographic Pattern (Unidentified) [original annotated 'wallpaper']

85 Photographic Pattern (Xanthosoma Lindenii)

86 Photographic Pattern (Marble?)

87 Photographic Pattern (Marble?)

89 Photographic Pattern (Unidentified Mexican? Architecture)

91 Photographic Pattern (Unidentified Mexican? Architecture)

93 Photographic Pattern (Façade, Mexico)

94 Photographic Pattern (Wicker Chair)

95 Photographic Pattern (Wicker Chair)

97 Photographic Pattern (Unidentified)

Notes

This book is an expanded version of an essay that appears in *Horst: Photographer of Style*, edited by Susanna Brown, which was published in 2014 to accompany a major exhibition of Horst's work at the Victoria and Albert Museum, London (6 September 2014 – 4 January 2015, then touring).

1 Horst records: 'All photographs are taken on Super XX Film. 120 Films developed in Defender 777. 4 × 5 Films developed in Kodak Developer DK 50. All enlargements on Opal G paper. Paper developer Kodak # 52.' Horst, *Patterns from Nature: Photographs by Horst*, New York (J.J. Augustin) 1946, p. ix. His negatives and prints are held by the Horst Estate, Miami, USA.

2 Horst, *Patterns from Nature*, p. vii.

3 *Ibid.*, p. viii.

4 Valentine Lawford, *Horst: His Work and His World*, New York (Alfred A. Knopf) 1984, p. 264.

5 *Ibid.*, p. 266.

6 'Patterns in Pictures by Horst', *Vogue* (American edition), 15 October 1946, pp. 192–93.

7 Horst, *Patterns from Nature*, p. viii.

8 Lawford, *Horst*, p. 264.

9 Horst, quoted in *ibid.*, pp. 264–66; emphasis in original.

10 Alexander Liberman, in Horst, *Patterns from Nature*, dust jacket (back flap).

11 Lawford, *Horst*, p. 266.

12 *Horst: Photographer of Style*, exhib. cat., ed. Susanna Brown, London, Victoria and Albert Museum, September 2014 – January 2015, then touring, p. 200.

13 *Horst: Patterns from Nature*, New York, Andrew Crispo Gallery, March–April 1977.

14 Horst, *Patterns from Nature*, p. 95.

15 Lawford, *Horst*, p. 266.

16 Ian Sommerville, quoted in *Taking Shots: The Photography of William S. Burroughs*, exhib. cat. by Patricia Allmer and John Sears, London, The Photographers' Gallery, January–March 2014, p. 57.

17 See *ibid.*, pp. 21–27 and 53–65.

18 'Patterns in Pictures by Horst', p. 192.

19 'Nature turns Designer', *House & Garden*, November 1946, p. 188.

20 *New York Times*, 10 June 1947, p. 32.

21 Horst, *Patterns from Nature*, p. 99; the Wesley Simpson Custom Fabrics, Inc. Swatch Book Archive, 1898–1950, New York Public Library, call no. JSN 08-2.

22 See Lynn Felsher, 'Wesley Simpson: Designer, Stylist and Entrepreneur', in *Silk Roads, Other Roads: Proceedings of the 8th Biennial Symposium of the Textile Society of America*, Smith College, Northampton, Mass., 26–28 September 2002.

23 Dilys Blum, 'Painting by the Yard: American Artist Designed Textiles 1947–57', in *Disentangling Textiles: Techniques for the Study of Designed Objects*, ed. Mary Schoeser and Christine Boydell, London (Middlesex University Press) 2002, pp. 109–18.

Bibliography

Blum, Dilys, *Painting by the Yard: American Artist Designed Textiles 1947–57*, in *Disentangling Textiles: Techniques for the Study of Designed Objects*, ed. Mary Schoeser and Christine Boydell, London (Middlesex University Press) 2002

Cowan, Andrew, *Horst: Platinum*, London (Jefferies Cowan) 2006

Felsher, Lynn, 'Wesley Simpson: Designer, Stylist and Entrepreneur', in *Silk Roads, Other Roads: Proceedings of the 8th Biennial Symposium of the Textile Society of America*, Smith College, Northampton, Mass., 26–28 September 2002

Horst, Horst P., *Horst: Photographs of a Decade*, ed. George Davis, New York (J.J. Augustin) 1944

———, *Patterns from Nature: Photographs by Horst*, New York (J.J. Augustin) 1946

———, *Salute to the Thirties*, photographs by Horst and George Hoyningen-Huené, notes on the plates by Valentine Lawford, New York (Viking Press) 1971

———, *Form: Horst*, Altadena, Calif. (Twin Palms) 1992

Horst Portraits: Paris, London, New York, exhib. cat. by Terence Pepper and Robin Muir, London, National Portrait Gallery, March–June 2001; Boston, Museum of Fine Arts, October 2001 – January 2002

Lawford, Valentine, *Horst: His Work and His World*, New York (Alfred A. Knopf) 1984

Tardiff, Richard J., and Lothar Schirmer, eds, *Horst: Sixty Years of Photography*, London (Thames & Hudson) 1991

Vogue's Book of Houses, Gardens, People, photographs by Horst, text by Valentine Lawford, London (Bodley Head) 1968

Acknowledgements

I should like to thank Andrew Cowan and Gert and Ursula Elfering for giving me generous access to the Horst archive, for being such excellent hosts and friends, and for their knowledge, enthusiasm, enjoyment and pivotal roles in making this book possible. I am especially grateful to my curatorial colleagues at the Victoria and Albert Museum – Susanna Brown, Marta Weiss, Anisa Hawes and Bronwen Colquhoun – who have assisted in the production of this book and, over the last few years, have shared with me their discoveries and knowledge of Horst's work. Mark Eastment and Anjali Bulley at V&A Publications, and Shawn Waldron, Senior Director of Archives and Records at Condé Nast, New York, have also kindly supported this project. Finally, I am indebted to Hugh Merrell and his publishing team, designer Nicola Bailey and editor Mark Ralph, for embracing this project, and for sharing their excitement to make it a reality.

Index

Page numbers in *italic* refer to the illustrations.

A

Adriantum Capillus-Veneris, Maidenhair Fern 19, 21
Agaricus campestris 25
Agave, Victoria Regina 30, *39*
Agave Rupicola 81
Art Nouveau 21

B

Bambusa 25
Bauhaus 14, 17
Bemelmans, Ludwig 30
Blossfeldt, Karl 15, 17, 21
 Delphinium 17
 Urformen der Kunst 17
 Wundergarten der Natur 17
Blum, Dilys 33
Bracket Fungus 45
Brassica Olerocea Variety, Cauliflower 20
Bronx Botanical Gardens 25
Brown, Susanna 21, 25
Burroughs, William S. 28

C

Caffery, Jamie 21
Calladium 67
Chanel, Coco 8
Chase, Edna Woolman 14
Coleus Blumei 57
Coward, Noël 8
Cupressus, Bark 19, 21

D

Dalí, Salvador 8, 30
David Crystal 30
Davidow 30
Davis, Bette 8
Dietrich, Marlene 8

E

Echevenia Gibbiflora Crispa 43
Ehrhardt, Alfred
 Das Watt 17
 Die Flut kommt 16
 Formendes Wind-Wasser 16

F

fabrics 28, 30, 33
Façade, Mexico 93
flowers 14
 Tulipa 20, 21

G

Goethe, Johann Wolfgang von 17

H

Haeckel, Ernst, *Kunstformen der Natur* 17
Hattie Carnegie 30
Hechtia glomerata 25
Hippopus Maculate, Shell 19, 21
Horst, Horst P.
 archive 33
 arrival in Paris 7
 and George Hoyningen-Huené 7–8
 Horst: Photographs of a Decade 8–9, 13
 and Jamie Caffery 21
 Kodak Negative Album 21, 22–23, 25, *25*
 Patterns from Nature: Photographs by Horst 12, 13, 14–25, 27, 30, 32–33
 photographic patterns 26, 27–30, *39–97*
 signature style 13
 sketchbook 24, 25
 and Valentine Lawford 8
 and *Vogue* 8
 and Warren Stokes 27
House & Garden 7
 'Nature turns Designer' 28
Hoyningen-Huené, George 7–8

L

Lawford, Valentine
 Horst and Jamie Caffery 21
 Horst and Warren Stokes 27
 Patterns from Nature 15
 relationship with Horst 8
Le Corbusier 7
Liberman, Alexander 17
Livistona Chinensis, Chinese Palm Fan 18

M

Mainbocher Corset 8, 9
Mallinson Fabrics, 'Camera Prints' 33
Marble 86

Mary Lee 30
minerals
 Pyrite, Mineral 19, 21
 Tourmaline, Mineral 18, 21

N

Nast, Condé 13
Nautilus Pompileus, Shell 20, 21
Neue Sachlichkeit 14
New Objectivity *see Neue Sachlichkeit*
New York Public Library 30
New York Times 28

P

Palm Trees 54, 55
Palmaceae, Palm Leaf 18, 21
patterns, matching 21
Penn, Irving, *Horst 6, 25*
Peperomia Sandersii 63
plants 14
 Adriantum Capillus-Veneris, Maidenhair Fern 19, 21
 Agave, Victoria Regina 30, *39*
 Agave Rupicola 81
 Bambusa 25
 Calladium 67
 Coleus Blumei 57
 Delphinium (Blossfeldt) 17
 Echevenia Gibbiflora Crispa 43
 Hechtia glomerata 25
 Livistona Chinensis, Chinese Palm Fan 18
 Peperomia Sandersii 63
 Spathiphyllum Wallisi 69
 Xanthosoma Lindenii 85
Prunus Pennsylvania Bark 51
Pyrite, Mineral 19, 21

R

Rhipdogoria Flabellum, Coral 20
Rorschach test 28

S

scarf designs 28, 30, *73*
Schiaparelli, Elsa 8
Sheeler, Charles 33
shells
 Hippopus Maculate, Shell 19, 21
 Nautilus Pompileus, Shell 20, 21
silk 28, *63*
Sommerville, Ian 28
Spathiphyllum Wallisi 69

Stehli Silks Corporation, 'Americana Prints' 30
Steichen, Edward 30, 33
Stokes, Warren 27
Strand, Paul 14
 Cobweb in Rain, Georgetown, Maine 16
 Rock by the Sea, Georgetown, Maine 16

T

textile design 30, 33, 38
Thuringia 15
Tourmaline, Mineral 18, 21
Townley Frocks 30
trees
 Cupressus, Bark 19, 21
 Cypress Root (Weston) 15
 Palm Trees 54, 55
 Palmaceae, Palm Leaf 18, 21
 Prunus Pennsylvania Bark 51
Tulipa 20, 21

U

Urform 17, 27
Urpflanze 17

V

vegetables
 Brassica Olerocea Variety, Cauliflower 20
Vertès, Marcel 30
Vogue 7–8, 13, 14
 Horst's photographic collages 28
 and *Patterns from Nature* 14, 15

W

wallpaper 28, *47, 59, 69, 83*
Wesley Simpson Inc. 28, 30
Weston, Edward 14
 Cypress Root 15
Wicker Chair 94, 95
Works Progress Administration 33

X

Xanthosoma Lindenii 85

First published 2014 by Merrell Publishers, London
and New York

Merrell Publishers Limited
70 Cowcross Street
London EC1M 6EJ

merrellpublishers.com

in association with

Victoria and Albert Museum
South Kensington
London SW7 2RL

vam.ac.uk

Published on the occasion of the exhibition *Horst:
Photographer of Style*, Victoria and Albert Museum,
London, 6 September 2014 – 4 January 2015

Text copyright © 2014 Victoria and Albert Museum
Illustrations copyright © 2014 the copyright holders;
 see right
Design and layout copyright © 2014 Merrell
 Publishers Limited

All rights reserved. No part of this publication
may be reproduced, stored in a retrieval system or
transmitted, in any form or by any means, electronic,
mechanical, photocopying, recording or otherwise,
without the prior written permission
of the publishers.

British Library Cataloguing-in-Publication Data:
A catalogue record for this book is available from
the British Library

ISBN 978-1-8589-4637-5

Produced by Merrell Publishers Limited
Designed by Nicola Bailey
Project-managed by Mark Ralph
Indexed by Vanessa Bird

Printed and bound in China

All images courtesy of and
© Condé Nast/Horst Estate,
with the exception of the
following:

Page 6: courtesy of R.J. Horst;
© The Irving Penn Foundation
© Condé Nast

Page 15: courtesy of the
National Art Library,
Victoria and Albert Museum;
© 1981 Center for Creative
Photography, Arizona Board
of Regents

Page 16 (top): courtesy of
the National Art Library,
Victoria and Albert Museum;
© Aperture Foundation Inc.,
Paul Strand Archive

Page 16 (bottom): courtesy
of the National Art Library,
Victoria and Albert Museum;
© Alfred Ehrhardt Stiftung,
Berlin

Page 17: courtesy of the
National Art Library, Victoria
and Albert Museum, and the
Karl Blossfeldt Archiv/Stiftung
Ann und Jürgen Wilde,
Pinakothek der Moderne,
Munich

Page 39: courtesy of the New
York Public Library

Page 91: courtesy of the New
York Public Library

Jacket: Horst P. Horst,
*Photographic Pattern (Agave,
Victoria Regina)*, 1946; see
page 39

Cover: Horst P. Horst,
*Photographic Pattern (Bracket
Fungus)*, 1946; see page 45

Frontispiece: Horst P.
Horst, *Photographic Pattern
(Unidentified)*, 1946; see also
page 41

Pages 10–11: Horst P. Horst,
*Photographic Pattern
(Peperomia Sandersii)*, 1946; see
also page 63

Pages 34–35: Horst P.
Horst, *Photographic Pattern
(Xanthosoma Lindenii)*, 1946;
see also page 85

Page 104: Horst P. Horst,
Prunus Pennsylvania Bark, 1946,
silver gelatin contact print
from Horst's Kodak Negative
Album, 6 × 6 cm (2¼ × 2¼ in.)

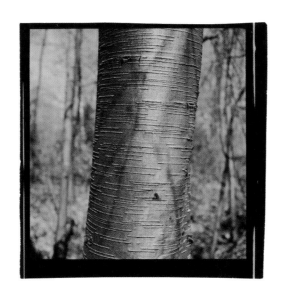